POSTCARD HISTORY SERIES

Boston's
South End

Laura A. Prescott

ON THE FRONT COVER: This postcard features an image of Columbus Avenue in 1912 and is mislabeled as Massachusetts Avenue. This block on Columbus Avenue is between West Canton and Yarmouth Streets. Two businesses featured in this photograph are Sonnabend's Loan Office, a pawn shop, and the Columbus Spa, which specialized in fruit and candy. (South End Historical Society Collections.)

ON THE BACK COVER: Pictured here is West Newton Street in the late 19th century. This glimpse of West Newton Street is taken from Columbus Avenue, looking toward Tremont Street. In the distance is the spire of the Evangelical Lutheran Zion Church, designed by architect Thomas Silloway. Today, the former church is the Jorge Hernandez Cultural Center. (South End Historical Society Collections.)

Boston's South End

Lauren Prescott

ARCADIA
PUBLISHING

Published by Arcadia Publishing
Charleston, South Carolina

Printed in the United States of America

Library of Congress Control Number: 2017948041

For all general information contact Arcadia Publishing at:
Telephone 843-853-2070
Fax 843-853-0044
E-mail sales@arcadiapublishing.com
For customer service and orders:
Toll-Free 1-888-313-2665

Visit us on the Internet at www.arcadiapublishing.com

To Mom,
who took me to the library

CONTENTS

ACKNOWLEDGMENTS

Without the assistance of certain people, this book would not have been possible. I would like to first thank Erin Vosgien, Arcadia's acquisition editor, for approaching me at a local history conference to pitch the book idea. To Liz Gurley, Arcadia's senior title manager, thank you for guiding me through the book writing process and answering all of my (many) questions.

This book would have not been possible without the support of my board of directors at the South End Historical Society. Thank you for hiring me as the organization's executive director and for entrusting me with this book project. All unaccredited images in this work appear courtesy of the South End Historical Society Collections. A special thank-you goes to Maryellen Hassell, whose encouragement and support has been vital over the past year.

I would also like to thank my fellow committee members at the South End History Collection: Alison Barnet, Ann Hershfang, Matthew Krug, Russ Lopez, and Judith Watkins. By welcoming me to the committee, you also welcomed me to the neighborhood. A special thanks to Alison Barnet, who has served as a wealth of knowledge not only for this book, but for any South End–related question I may have. If not for her timeline of the South End, many parts of this book would be missing.

To archivist Marta Crilly at Boston City Archives, thank you for answering all of my last-minute questions and requests. To my friend Corinne Bermon, thank you for stepping in as editor and making this text worthy of publishing. To my family and friends, thank you for listening to me endlessly discuss this book project over the past year, and for your support and patience.

Finally, to my husband, Adam Prescott, thank you for moving country for me.

INTRODUCTION

Boston's South End is a unique neighborhood. Until the early 19th century, the Victorian row house district we know today was marshland. A narrow strip of land known as the Boston Neck (today's Washington Street), connected Boston proper on the Shawmut Peninsula with the mainland town of Roxbury. During this time, the neighborhood known as the South End was the area of Milk, Summer, and Franklin Streets. As the geographic boundaries of Boston changed, so did the South End neighborhood.

By 1801, the City of Boston proposed to create a new residential neighborhood. Charles Bulfinch and other Boston selectmen presented a plan to develop the marshland around the Boston Neck. This new residential area was originally meant to include freestanding houses surrounded by large gardens and grounds. This ambitious plan was not successful, and few people purchased land on the Neck during this time. After 10 years, Boston noted that there was no demand for the 50 acres of land, and by 1814, people purchased only a handful of lots on and around Washington Street.

About 25,000 people lived in Boston in 1800, but by 1880 that number surged to 362,839. One main contributor to the city's population boom was immigration. Foreign immigration swept into Boston in two waves, with the first beginning in the 1840s. As the city's population grew, tenement housing began to dominate. The City of Boston had to reevaluate its plans for the South End, and in the 1828 Stephen Palmer Fuller developed plans for a row house district that included additional streets and smaller, less expensive lots. With these plans, Boston hoped to prevent middle-class and upper-middle-class families from leaving the city for the surrounding towns. Fuller's plan was not as successful as Boston hoped, but it did solidify the South End as a row house district.

The establishment of railroads was another factor in the development of the South End. Chartered in 1831, the Boston & Providence Railroad ran over the Charles River Basin. This polluted the shores and the combined stench of stagnant water and dying salt marshes along with fears of disease led to the public's support for filling in the Back Bay. The City of Boston and the Boston Water and Power Commission began to fill in the area and this land-making project led to the creation of Back Bay. The project also included land north of Washington Street in the South End.

The few wealthy families that lived in the South End moved away within 10 to 15 years, many moving to the Back Bay neighborhood. Wealthy residents saw Back Bay as a more desirable area to live due to its proximity to downtown Boston and the Public Garden, and also because architects built the neighborhood in the French style, a popular style that swept the nation in the mid-19th century. In contrast, the South End is based on an English model and design, which faded in popularity in the 19th century. By the time the city built Back Bay, the South End, to many, seemed a dated neighborhood.

In the late 19th century, the South End evolved from a relatively wealthy residential neighborhood with single-family row houses to a tenement and lodging house district. For decades, the South End reigned as the largest lodging house district in Boston. In 1918, of the 5,000 licensed lodging houses, the South End had 3,200.

Despite fading in popularity with wealthy, white Protestant families, the South End evolved into a diverse working-class and immigrant enclave. The first group to move into the neighborhood were Irish Catholics, but soon the South End became home to Italians, Syrian-Lebanese, Greeks, Chinese, Portuguese, French Canadians, and a burgeoning black middle-class. To meet the needs of the neighborhood's working-class community, building owners established restaurants, cafes, bars, grocers, drugstores, and other businesses on the street level of buildings. The South End may not have been a desirable area for the wealthy, but the neighborhood was full of entertainment. Here, one found whatever they were looking for: lively restaurants and bars, theaters and operas to frequent in the evenings, and, in the 20th century, people flocked to the South End to listen to live jazz music.

The book is almost entirely comprised of postcards from the South End Historical Society's rich collection. Postcards became popular in the 19th century as a form of communication. John Charlton created the first commercially produced postcard in 1861 in Philadelphia, Pennsylvania. Charlton patented the postcard and sold the rights to Hymen Lipman. Lipman's postal cards included a decorated border but contained no images. Despite its increasing popularity, the US Post Office was the only institution allowed to print postcards until Congress passed the Mailing Card Act on May 19, 1898. This allowed printers and publishers to create postcards, although they were called "souvenir cards" until 1901.

Between 1898 and 1915, a postcard craze known as the Golden Age of Postcards captivated the world. In 1905 alone, people mailed over seven billion postcards worldwide, and this does not include those purchased for personal collections. The popularity of postcards encouraged more businesses, especially local family-run businesses, to get involved. Some of the South End Historical Society's more interesting postcards are snapshots of family-run businesses, such as Sonnabend's Loan Shop on Columbus Avenue or the Frank Janes drugstore on the corner of Massachusetts and Columbus Avenues.

This book is organized into seven chapters and discusses the history of the South End from its emergence in the 19th century to the mid-20th century, before urban renewal gripped the neighborhood. It includes postcards of hotels, restaurants, churches, schools, hospitals, businesses, and street views of the South End. It is important to note that this book is not a complete history of the South End. Where possible, photographs and stereoviews fill in the gaps, yet other gaps remain. The book does not tackle the complexity of the South End in the 20th century, when urban renewal demolished the New York Streets neighborhood in 1955, or the 1960s and 1970s, when gentrification moved in and slowly began to push out the South End's diverse working-class community. There are numerous books dedicated to the neighborhood's recent history, but *Boston's South End* focuses on the first century of the South End's story.

One

A Neighborhood Emerges

Part of the present-day South End was once part of South Bay. Bostonians were concerned that this tidal bay would erode the Boston Neck, which was the sole overland link between Boston proper and the mainland town of Roxbury. In 1785, the town committee recommended that a seawall be built on the Neck to prevent erosion and protect traveling passengers. Boston could not afford the project and granted land to residents to build and maintain a seawall. Residents failed to maintain the seawall, and Boston proposed a new plan in 1801 to create a new residential neighborhood by developing the marshlands along the Neck. Architect Charles Bulfinch and other Boston Selectmen originally envisioned freestanding houses surrounded by gardens and grounds. However, few people purchased these lots and city officials had to rethink their plans for the neighborhood. The solution to their problem arrived with the city's newcomers.

Between 1840 and 1880, Boston saw an increase in its population. One main contributor to Boston's population boom was immigration, and with a thriving population and limited housing, city officials feared its middle-class and upper-middle-class residents would flee to the suburbs. To keep this tax base within city limits, Boston reevaluated its plan for the Neck and resolved to create a row house district. By planning more streets and dividing blocks into smaller lots, the city hoped to attract a wider demographic. Through this new plan, a neighborhood emerged.

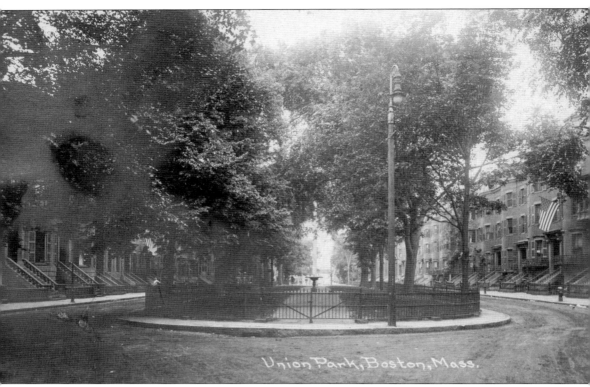

Between 1850 and 1851, the City of Boston laid out three residential squares in the South End: Chester Square, Worcester Square, and Union Park. Originally called Weston Street, Union Park was laid out by city engineers William P. Parrot and Ellis S. Chesbrough beginning in 1851. The row houses on Union Park were built between 1851 and 1859, the first being No. 45. The buildings are surrounded a 16,000-square foot park with two cast-iron fountains and a lotus-style fence similar to Louisburg Square on Beacon Hill. The garden in Union Park was only one third of an acre, compared to one and a half acres in Chester Square. However, the City of Boston hoped that Union Park's proximity to downtown Boston would make up for the small green space. Of the three residential squares, Union Park is the only one that has remained largely intact.

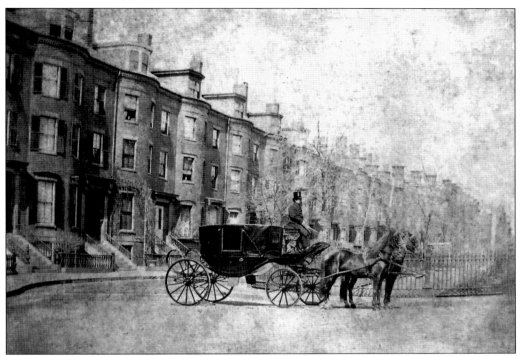

This photograph shows Union Park in the 1860s. The original cast-iron fountain in Union Park was painted white and included a statue of Leda and the Swan. Several prominent Bostonians lived on Union Park, such as Alexander H. Rice at No. 34. He was the mayor of Boston, a US representative during the Civil War, and the thrice-elected governor of Massachusetts.

The City of Boston laid out Chester Square in 1850, and it was the largest of the South End's original residential squares. It included several walking paths and a three-tiered cast iron fountain in the center, pictured here. A lotus-style fence, similar to Louisburg Square in Beacon Hill, enclosed the square.

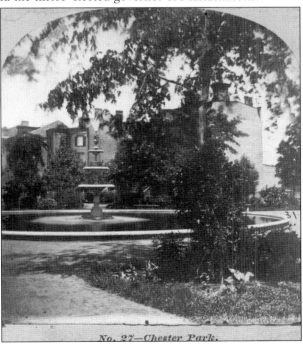

No. 27—Chester Park.

Chester Square was adjacent to nearby blocks, named Chester Park, West Chester Park, and East Chester Park. The City of Boston changed the Chester addresses to Massachusetts Avenue in 1894. Five decades later, the City of Boston replaced the square with four lanes of traffic to accommodate cars from Interstate 93.

Concord Square, originally part of Concord Street, was renamed in the mid–19th century. Boston began laying out Concord Square's garden in 1866 in two sections and installed a cast-iron fountain between the two gardens in 1868. The homes on Concord Square were cheaper than the neighborhood's original residential squares (Chester Square, Worcester Square, and Union Park) and were purchased by employees rather than business owners.

In 1859, the City of Boston decided to rename the section of Rutland Street between Columbus Avenue and Tremont Street as Rutland Square. The city began to lay out a long, narrow garden in Rutland Square in 1866. Because many of the homes on Rutland Square were already built, the garden was not as large as Union Park, Chester Square, or Worcester Square. The garden in Rutland Square was so narrow that it was not originally fenced in. Pictured here is 36 Rutland Square. Boston City Directories list Judith Walker Andrews (1826–1914) as the owner and resident from at least 1878 to 1896. Andrews was a philanthropist and chairperson of the Ramabai Association in Boston, which sought to help Pandita Ramabai in her mission to educate women in India. Ramabai was an Indian pioneer in education and social reformer.

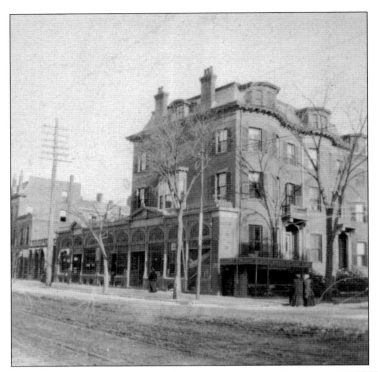

Pictured here is 504 Massachusetts Avenue in 1896, at the corner of Tremont Street. Charles and Elizabeth Wood lived here with their daughter Mary. Charles was a real estate and insurance dealer and previously lived at 78 Commonwealth Avenue in Back Bay. He also owned and operated the Hotel Vendome on Commonwealth Avenue.

This is another view of Chester Square, taken from 504 Massachusetts Avenue in 1896. Note the cupola atop the row house on the right. A cupola provided a lookout for homeowners, and this architectural detail was common in the United States in the 19th century. Many South End cupolas were lost in the 20th century due to the difficulty of maintaining them.

Rev. Robert Cassie Waterston (1812–1893) purchased 71 Chester Square (526 Massachusetts Avenue) in 1863 and lived here during the second half of the 19th century. He served as pastor of the Pitts Street Unitarian Chapel and the Unitarian Church of the Savior. Pictured here is Waterston's library. The elaborate interior reflects the typical Victorian style of the period.

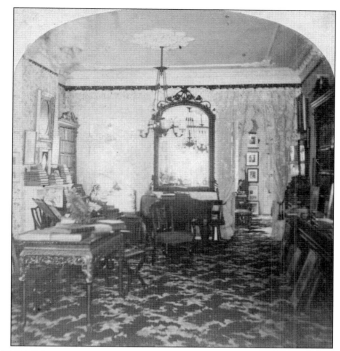

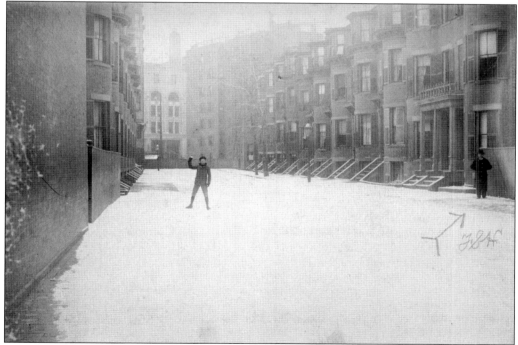

St. Charles Street is a small street at the edge of the South End, between Berkeley and Cazenove Streets. Row houses were built on the street as early as 1871. Pictured here is a young boy poised to throw a snowball in February 1896. To the right is an unidentified man with the initials F.S.H.

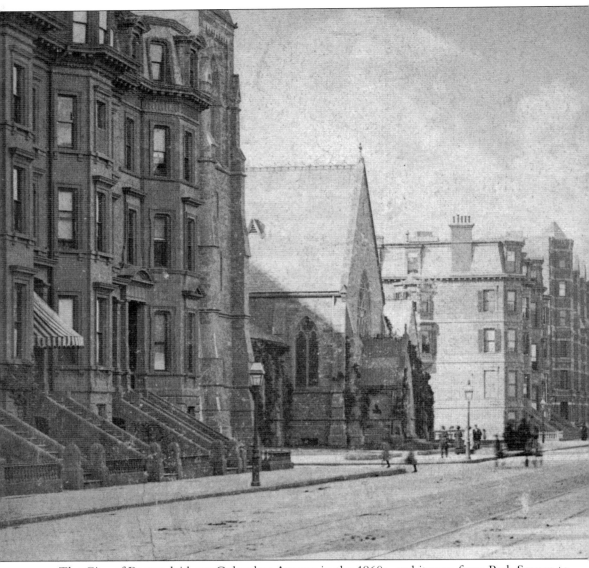

The City of Boston laid out Columbus Avenue in the 1860s, and it runs from Park Square to Northeastern University. This is an 1880s photograph of Columbus Avenue. On the left is Union Congregational (today's Union United Methodist Church), and in the distance, one can see the spire of the Second Universalist Church on the corner of Clarendon Street. Columbus Avenue was originally paved with wooden blocks to muffle traffic and was repaved with asphalt in 1912. The later buildings and streets in the South End were not as grand as its residential squares, and

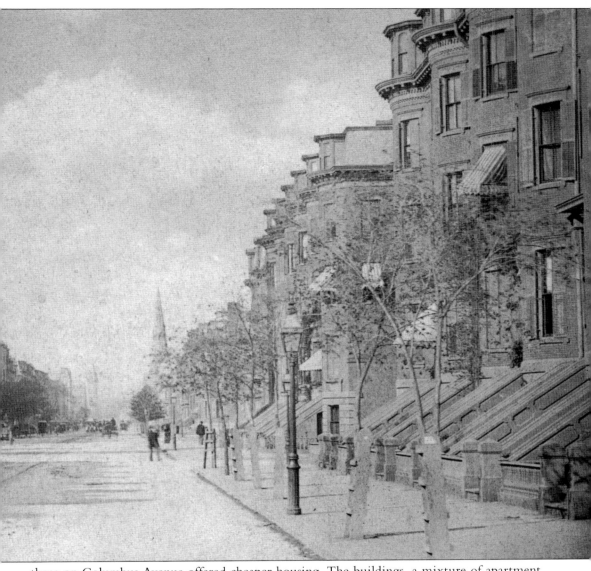

those on Columbus Avenue offered cheaper housing. The buildings, a mixture of apartment hotels and single-family row houses, lowered the neighborhood's prestige. The South End was a fashionable residential neighborhood only through the 1860s. The combination of the new Back Bay neighborhood as well as the financial panic of 1873 caused many of the South End's original inhabitants to move out of the neighborhood.

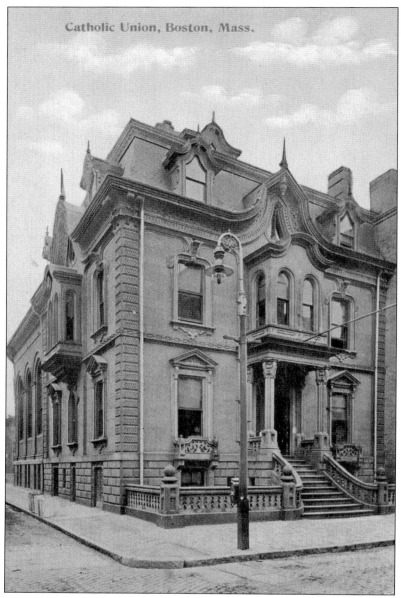

Catholic Union, Boston, Mass.

John J. McNutt built 1682 Washington Street for wealthy furniture dealer Aaron Hall Allen in 1859. Known as the Allen House, the building is a blend of Italianate and French Second Empire styles, with carved ornamentation that reflects the furniture design of the era, a clever addition to a furniture dealer's home. Throughout its history, the Allen House was home to a succession of social clubs that reflected the changing neighborhood. Allen lived in the building for only 12 years before moving to Back Bay. He leased the building to the Central Club, a local organization for prominent men. After the Central Club, the Catholic Union owned the building, remodeling and adding a large auditorium and a basement bowling alley. In the 20th century, the Allen House was home to the Lebanese-American Club of Boston, but the organization was unable to maintain the building. Abandoned for several decades, the Allen House was restored and converted into housing in the late 1990s.

In 1829, the City of Boston decided to improve access to the Neck to increase sales. The Neck was an isthmus that connected Boston proper to the mainland. The city extended Tremont Street by building a dike and filling in the flats along the edge. The filling of Tremont Street continued into the 1830s. This is a mid–19th century photograph of Tremont Street, looking north from West Springfield Street.

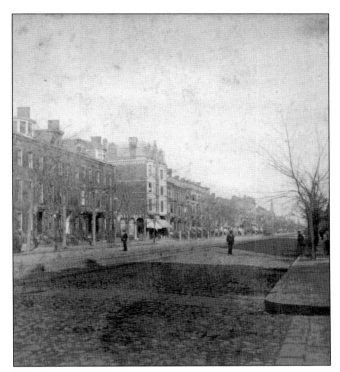

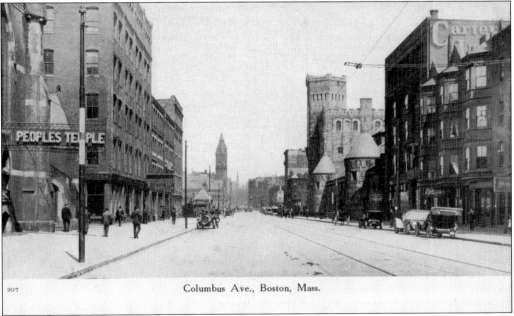

Columbus Ave., Boston, Mass.

This photograph of Columbus Avenue was taken at the corner of Berkeley Street in the early 20th century. On the left is the People's Temple, a Methodist Episcopal church that seated 4,000 people. On the right is the armory for the First Corps of Cadets. This armory, designed by William Gibbons Preston, was built between 1891 and 1897 to withstand potential unrest and riots from Irish immigrants and anarchists—a riot which never materialized.

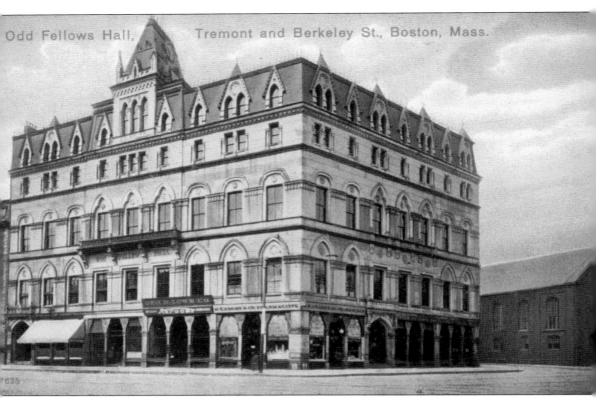

Odd Fellows Hall, Tremont and Berkeley St., Boston, Mass.

Built in 1872 for the Independent Order of Odd Fellows, Odd Fellows Hall was located on the corner of Tremont and Berkeley Streets. Occupying 12,000 square feet, the grand four-story building was constructed of Concord and Hallowell white granite. The Independent Order of Odd Fellows was a politically and religiously independent fraternity, founded in 1819 by Thomas Wildey in Baltimore, Maryland. Still in existence, the purpose of the organization is to provide a framework that promotes social and personal development. Early in the morning on January 4, 1932, the building erupted in flames. The five-alarm fire was so large that the adjacent Clarendon Hotel evacuated all 300 guests. The building was not able to be saved, and today it is the site of a large condominium and several businesses.

The Theodore Parker Memorial Hall was built in 1872 on the corner of Berkeley and Appleton streets for the 28th Congressional Society and the Parker Fraternity. Although it has a Star of David window, this building was a Unitarian meetinghouse. It was named for the Unitarian minister, abolitionist, and transcendentalist Theodore Parker. The building later served the Jewish community as Adath Israel's religious school in the late 19th century.

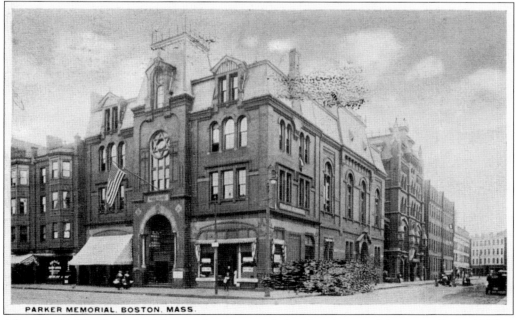

PARKER MEMORIAL, BOSTON, MASS.

After World War I, the building no longer served the church or social groups. From 1967 to 1971, the building housed the Boston Tea Party concert venue, which attracted famous artists and bands, such as Jimi Hendrix, Led Zeppelin, Grateful Dead, Fleetwood Mac, and The Who.

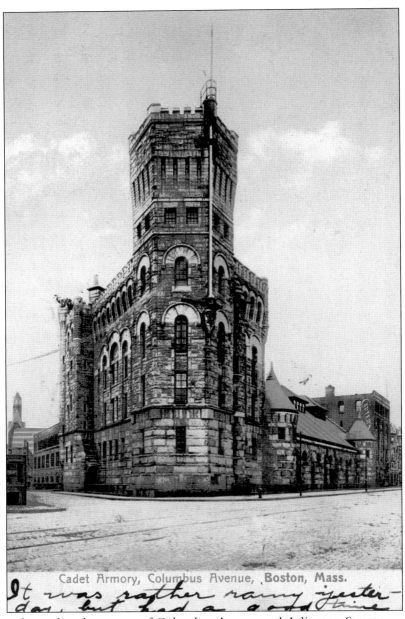

Cadet Armory, Columbus Avenue, Boston, Mass.

It was rather rainy yester-
day, but had a good time

The armory located at the corner of Columbus Avenue and Arlington Street was originally built for the First Corps of Cadets. Profound changes were taking place in the city in the late 19th century. The population increased by 25 percent each decade and the influx of immigrants (mainly Irish, Italian, Polish, Jewish, Greeks, Armenians, Chinese and Syrians) were perceived as threatening to many established Americans. In addition, many of these immigrants worked long hours under deplorable conditions for low wages, potentially creating a tense situation. Boston became the hub for labor organizations seeking to improve the working conditions of Americans. Parades and strikes for better living and working conditions made disorder seem inevitable. This grand fortress in the middle of the city was built not only as a symbol of strength, but also as an actual defense against civil disturbances and riots—which never happened.

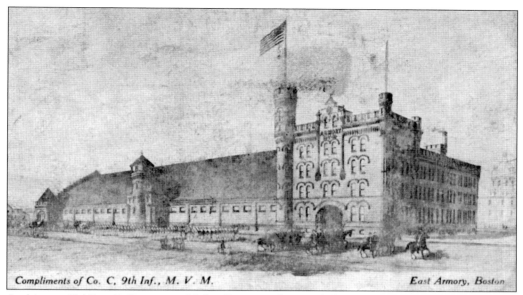

Compliments of Co. C, 9th Inf., M. V. M. East Armory, Boston

Architects Gridley F. Bryant and John F. Eaton designed the East Armory on East Newton Street in 1889. It was built for the Massachusetts Volunteer Militia for the National Guard. Armories were popular in the late 19th century when the National Guard served as the nation's peacekeeper and defense against civil unrest. The city demolished the armory in 1963, and the Solomon Carter Fuller Mental Health Center is now located on the site.

West Newton Street runs from Washington Street (at Blackstone Square) to Huntington Avenue in Back Bay. This late-19th-century postcard looks down West Newton Street from Columbus Avenue. On the far right is Mitchell & Gaynor Druggists, which is today the location of the Wine Emporium. Note the spire of the Evangelical Lutheran Zion Church in the distance. Today, that building is the Jorge Hernandez Cultural Center.

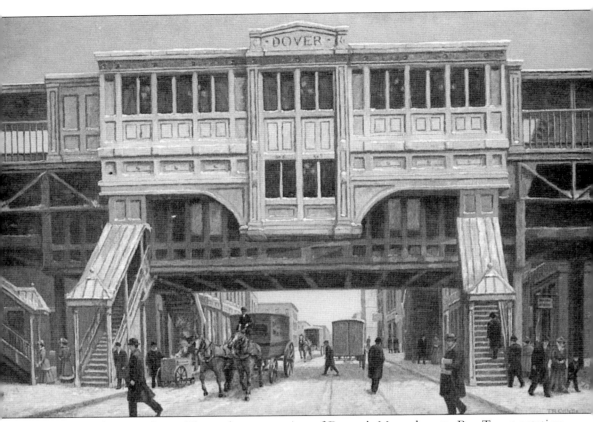

The Washington Street Elevated was a section of Boston's Massachusetts Bay Transportation Authority (MBTA) subway and opened on June 10, 1901. Known as the "El," this elevated segment of the Orange Line ran from Chinatown, through the South End and Roxbury and ended in Jamaica Plain at Forest Hills. The South End had two elevated stations: Northampton and Dover. Dover station was located on Dover Street (today's East Berkeley). Architect Alexander Wadsworth Longfellow, Jr (nephew of Henry Wadsworth Longfellow) designed the station in a Beaux-Arts style. Residents remember the Washington Street Elevated for the good and the bad. The El connected communities and provided a quick ride from Roxbury to downtown Boston, but the noise it emitted as it rumbled down Washington Street plagued others. The Washington Street Elevated ran until April 30, 1987, when it was rerouted along the Southwest Corridor. (Alison Barnet).

Two

CARING FOR THE ILL

The South End was a popular hospital district, with at least eight hospitals emerging over the course of its history. The city's first municipal hospital, Boston City Hospital, opened in 1864 on the location of the old Agricultural Fairgrounds. Before the establishment of Boston City Hospital, Bostonians relied on Massachusetts General Hospital, a private hospital that could not meet the needs of Boston's expanding population. The neighborhood was also home to smaller hospitals, such as St. Elizabeth's Hospital and the Plymouth Hospital & Nurses' Training School. Founded in 1908 by Dr. Cornelius Garland, a prominent black physician, Plymouth Hospital opened at 12 East Springfield Street. This integrated hospital trained black nurses and staff when white facilities barred them from their staff and training schools.

The neighborhood also possessed its share of innovative medical professionals, such as Solomon Carter Fuller, the country's first black psychiatrist. Born in Liberia, Dr. Fuller studied at the Boston University School of Medicine in the South End. Over the course of his career, Dr. Fuller made significant contributions to the study of Alzheimer's disease. In 1976, Boston University opened the Solomon Carter Fuller Mental Health Center on East Newton Street.

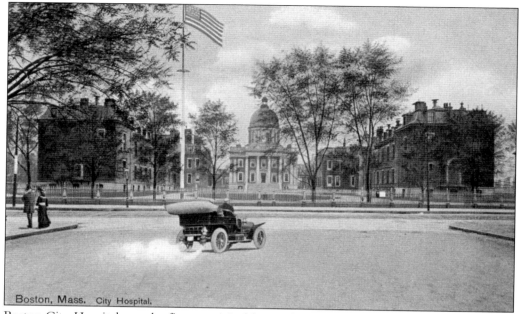

Boston, Mass. City Hospital.

Boston City Hospital was the first municipal hospital in the United States and was located on Harrison Avenue between East Concord and Massachusetts Avenue. The city built the hospital between 1861 and 1864 to cater to Boston's poorer residents. The postcard shows a view of the hospital from Worcester Square, with the impressive domed administration building in the center.

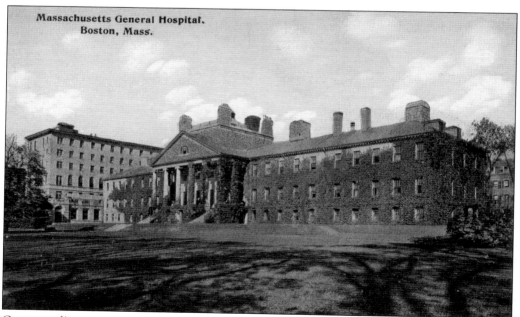

Massachusetts General Hospital.
Boston, Mass.

Overcrowding was one of the main reasons for the establishment of Boston City Hospital. In the early 19th century, the city's main hospital, Massachusetts General Hospital, frequently battled overcrowding and was unable to meet the public needs. Massachusetts General Hospital turned away 25 percent of people for treatment, highlighting the need for a city hospital.

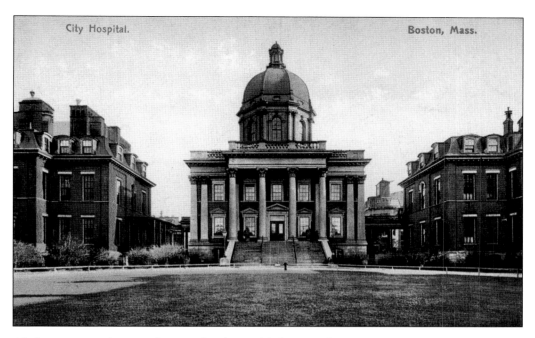

Cholera was another justification for the establishment of Boston City Hospital. The disease spread east from Philadelphia to New York City, giving Boston ample time to prepare for an outbreak. The city established a hospital for cholera in a building on Fort Hill and treated patients for five months. Officials viewed the hospital as successful, though 166 of their 262 (63 percent) patients died in their care. Yet the hospital's treatment of patients was consistent with the care and scientific standards of the 19th century. City officials believed they could establish a new city hospital based on this example.

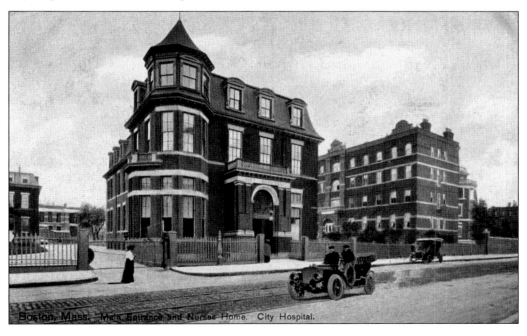

Boston, Mass. Main Entrance and Nurses Home. City Hospital.

27

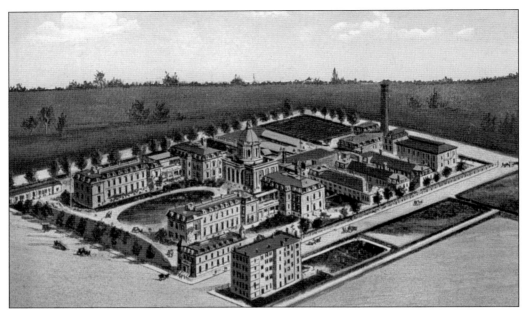

Overcrowding justified the need for a city hospital, but where would it be? Boston found the answer in Elisha Goodnow's will. Goodnow was the second patient to undergo surgery at Massachusetts General Hospital. Grateful for the care he received, Goodnow left property in his will valued at $25,000 for the establishment of a city hospital. The will stipulated that Boston build a hospital in either Fort Hill in Roxbury or the South End.

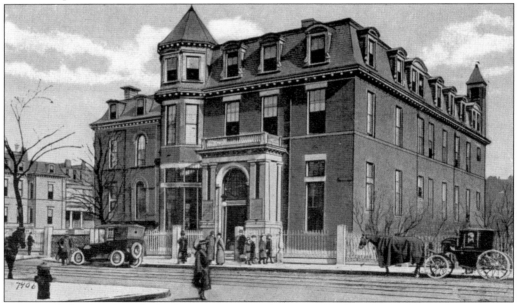

Despite Elisha Goodnow's death in 1851, ground was not broken for the hospital until 1861. In 1860, a total 14 architects submitted plans for the new hospital and the city chose Gridley F. Bryant's. A renowned architect, Bryant is also responsible for designing the Massachusetts State House, Quincy Market, and the Old City Hall on School Street. After three years of construction, the hospital dedication took place on May 24, 1864.

Boston City Hospital was originally comprised of three buildings. At the center was its administration building, with a dome soaring above the South End. Interestingly, the administration building's dome served as the operating room. Staff moved patients from the surgical pavilion to the administration building and used a hand elevator to reach the operating room. Despite this inconvenient arrangement, it served as an operating room for 12 years.

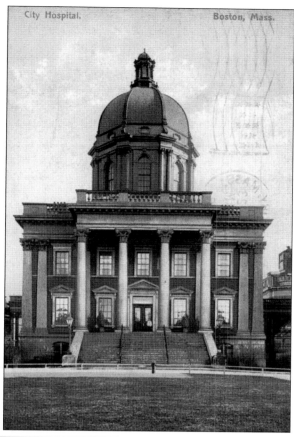

City Hospital. Boston, Mass.

The South Department for infectious diseases opened in August 1895 on Massachusetts Avenue, on land that once housed Boston's greenhouses. During the 1880s, some of the most prevalent infectious diseases were diphtheria and scarlet fever. The mortality rate for diphtheria in Boston exceeded every other major city in the United States.

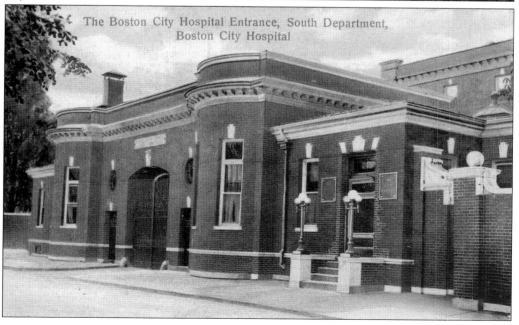

The Boston City Hospital Entrance, South Department, Boston City Hospital

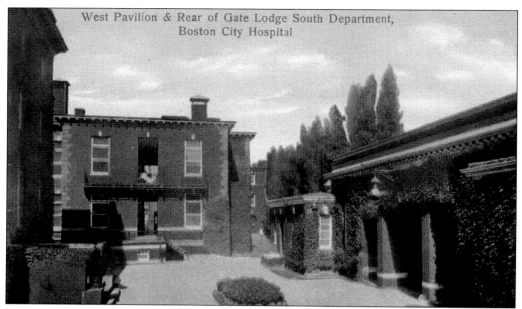

West Pavilion & Rear of Gate Lodge South Department, Boston City Hospital

Overcrowding and the risk of spreading diseases to staff and other patients led to the creation of the South Department in 1895. To prevent the spread of disease back to the main hospital, the South Department had its own staff and ambulance service. As the medical field advanced and infectious diseases became less threatening, separate buildings were no longer needed, and the South Department closed in 1960.

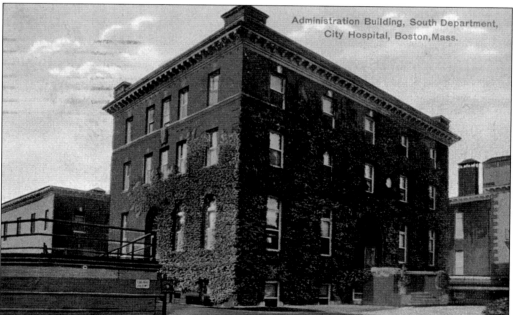

Administration Building, South Department, City Hospital, Boston, Mass.

The South Department was the first hospital for contagious diseases in the United States. Seven buildings formed the department, including two buildings for patients, an administration building, a laundry building, and housing for nurses. For easy cleaning and disinfection, the hospital used Terrazzo pavement and glazed brick for the floors and walls.

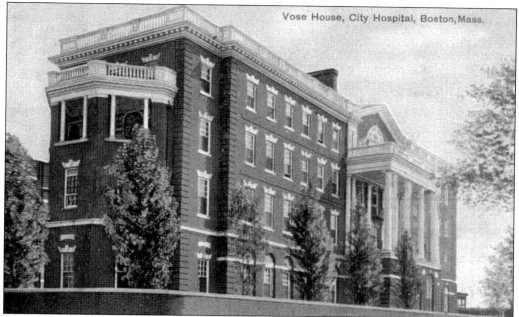

Vose House, City Hospital, Boston, Mass.

Boston City Hospital's original accommodation for nurses was insufficient for its growing staff. On November 23, 1897, work began at the corner of Massachusetts and Harrison Avenues on the Vose House. Ann White Vose bequeathed $100,000 to the hospital for a new nurses' facility, and it opened in 1900. The Vose House was across Harrison Avenue from Boston City Hospital's stately administration building. The new building housed 97 nurses and included a kitchen, dining room, and a large reception hall. Boston City Hospital built the four-story building with red brick and marble trimmings. Its architectural style is akin to buildings in the South Department.

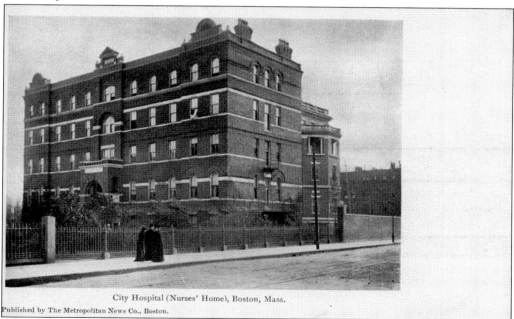

City Hospital (Nurses' Home), Boston, Mass.

Published by The Metropolitan News Co., Boston.

31

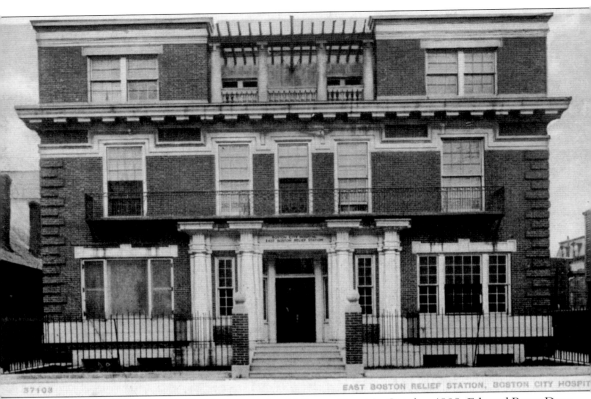

The East Boston Relief Station opened at 14 Porter Street in October 1908. Edward Percy Dana designed the three-story brick building in the Classical Revival and Craftsman style. It was the second relief station for Boston City Hospital (the first being the Haymarket Relief Station in 1902). In the early 20th century, Charlestown and East Boston saw an increase in jobs related to transportation, manufacturing, steamships and railroads, causing a greater amount of physical injury to employees. Boston City Hospital created the relief stations to serve not as a hospital, but as a medical facility and 24-hour clinic with bilingual staff to accommodate the city's non-English-speaking population. The East Boston Relief Station even had its own ambulance service with a two-story ambulance stable on site. Today, the building still serves the East Boston community as part of the North Suffolk Mental Health Association.

In the late 19th century, the South End was home to a growing number of black families. Despite this, Boston City Hospital (and other hospitals) did not hire black physicians or accept black students in its training programs. Dr. Cornelius Garland, a prominent black physician from Alabama, moved to Boston in 1902 after receiving his Doctor of Medicine. Garland found discrimination within the medical field for years before establishing his own hospital. The Plymouth Hospital & Nurses' Training School opened in 1908. The hospital was located nearby Boston City Hospital at 12 East Springfield Street and was open to all. This integrated hospital trained black nurses and staff who were barred from other institutions until its closing in 1928. A year later, Boston City Hospital began admitting people of color into their medical training programs, although the hospital did not hire its first black physician until 1949.

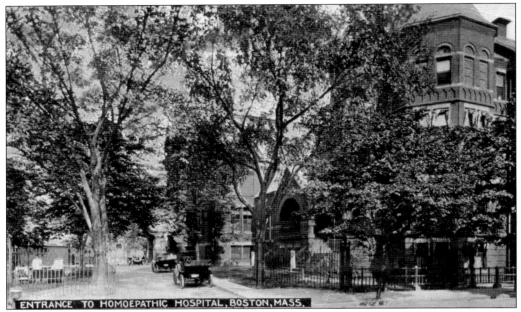

ENTRANCE TO HOMOEPATHIC HOSPITAL, BOSTON, MASS.

Israel Tisdale Talbot, a homeopathic physician, envisioned a homeopathic hospital in Boston and raised funds for its establishment. Talbot is also responsible for cofounding the New England Female Medical College, the world's first for women. Established in 1855, the Massachusetts Homeopathic Hospital opened its doors in Jamaica Plain in 1871. Three years later, the hospital moved to a newly built site in the South End in what is now the Talbot Building.

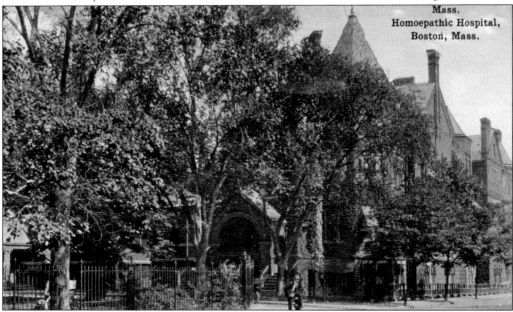

Mass.
Homoepathic Hospital,
Boston, Mass.

German physician Samuel Hahnemann created homeopathy, a system of alternative medicine, in 1796. Hahnemann was dissatisfied with the medical profession and believed certain medical procedures achieved more harm than good. In the United States, homeopathy arrived with Dr. Hans Burch Gram, who opened the first homeopathic facility in 1825 in New York City.

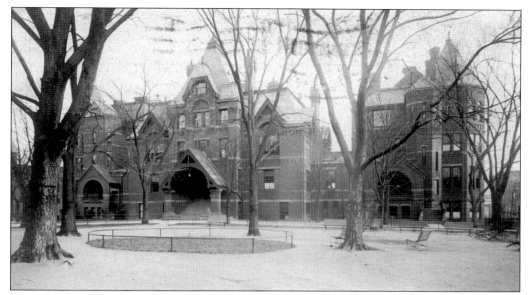

Although homeopathy is an ineffectual treatment for any condition, it found success in the 19th century. At the time, orthodox medicine relied on ineffective treatments that were often dangerous and medications often contained arsenic, lead, or mercury. The building pictured here is now known as the Talbot Building (named after Israel Tisdale Talbot) and part of Boston University's School of Public Health.

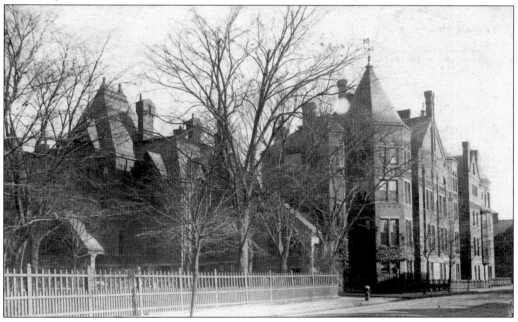

Architect William Ralph Emerson designed the Massachusetts Homeopathic Hospital in 1874 in the Victorian Gothic style. John Ruskin and Augustus Welby Northmore Pugin were major proponents of the Gothic style. Defined by multicolored decoration and Gothic details, the style drew influence from English, French, and German medieval buildings. The Victorian Gothic style became popular in the America after the Civil War, especially for public buildings.

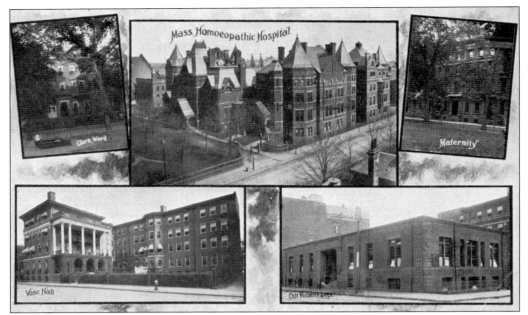

The Massachusetts Homeopathic Hospital expanded over time, with a surgical wing in 1884 and a training school for nurses in 1885. The hospital continued to offer more for women with a maternity ward and the Vose Hall for nurses in 1897. By 1916, the Massachusetts Homeopathic Hospital was the second largest hospital in Massachusetts.

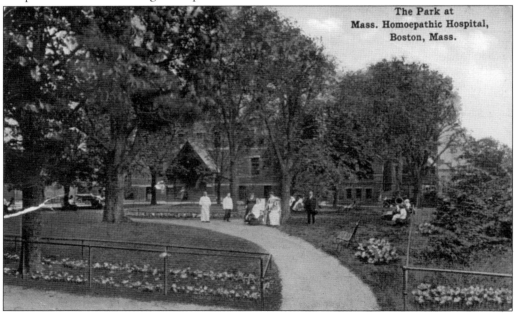

As modern medicine advanced, the Massachusetts Homeopathic Hospital abandoned its homeopathic practices. Dr. Alonzo Boothby performed the first successful kidney removal in New England at the hospital. In 1929, the Massachusetts Homeopathic Hospital merged with the Massachusetts Memorial Hospitals. Today, the main building survives and is part of the Boston University School of Public Health.

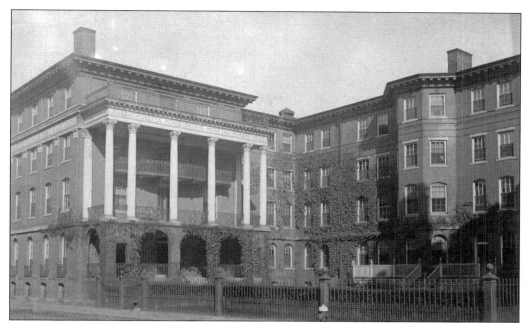

Not to be confused with the Vose House for Boston City Hospital, Vose Hall for Nurses was built for the Massachusetts Homeopathic Hospital on Stoughton Street in 1897. Ann White Vose bestowed money in her will to several Boston hospitals, on the condition that they erect the building in her name.

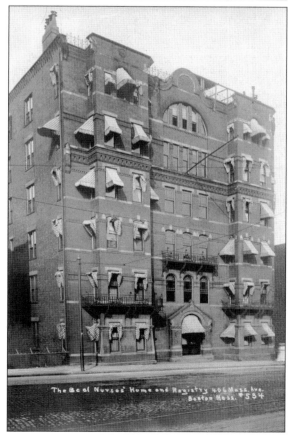

The Beal Nurses' Home and Registry found its beginnings in 1907 at 406 Massachusetts Avenue, known as the Hotel Palmerston. The six-story brick building provided housing for private nurses not affiliated with hospitals in the area. The idea of private, hourly nurses in Boston emerged in 1913, and they would provide care in hotels, lodging houses, or private homes. By 1914, the Beal Nurses' Home had moved to 20 Charlesgate West.

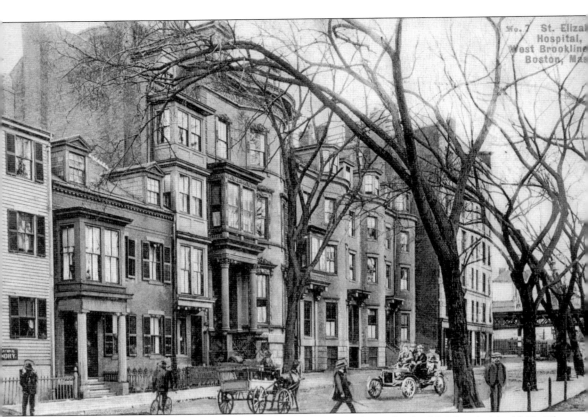

The Sisters of the Third Order of St. Francis established St. Elizabeth's Hospital in 1868. They founded the hospital to treat women, especially those who could only afford moderate fees for medical treatment. The hospital's first location was at 78 Waltham Street in the South End, moving to West Brookline Street in 1885. The hospital, located across from Blackstone Square, occupied several buildings on West Brookline Street with its entrance at No. 61. This building was the former home of Justin Winsor, superintendent of the Boston Public Library, librarian at Harvard University, and one of the founders of the American Library Association. Although smaller than other hospitals in the South End, St. Elizabeth's Hospital had multiple wards, including a surgical, medical, obstetrical, and gynecological ward. Today, St. Elizabeth's Medical Center is in Brighton and affiliated with Tufts University.

Three

PLACES OF WORSHIP

In the 19th century, churches rose above the sea of brick row houses and mansard roofs in the South End. Religious institutions emerged on almost every street and most denominations had their own place of worship. This great mixture of congregation in the South End included Unitarians, Methodists, Baptists, Episcopalians, Catholics, and Jewish institutions. Some churches housed three or four congregations. Nearly all churches built in the South End in the mid-19th century were for middle-class and upper-middle-class residents. Yet, as the neighborhood changed from a wealthy residential district to a working class and immigrant enclave, religious institutions needed to evolve as well. If not, they faced diminished funds and membership, forcing congregations to move or dissolve altogether.

In the 20th century, arson plagued several South End churches, and few survived the damage. Today, developers have converted most of the remaining churches into housing. While no longer a place of worship, they have preserved the exterior for future generations. Out of all the changes the neighborhood has experienced, one thing has remained constant: churches in the South End continue to dominate the streetscape.

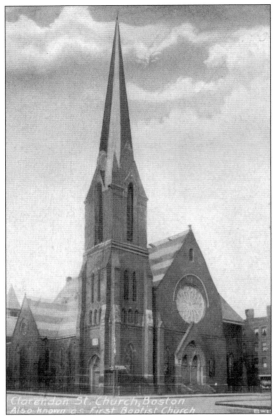

Architect Samuel J.F. Thayer designed the Clarendon Street Baptist Church. The Gothic-style building included a 215-foot spire. The Rowe Street Baptist Church, located in an increasingly commercial downtown district, moved in 1869 to its new South End building. Adoniram Judson Gordon, the church's first pastor, founded the Boston Missionary Training School in its basement, which grew into today's Gordon College in Hamilton, Massachusetts.

The Clarendon Street Baptist Church, which numbered over a thousand congregants at one point, was the last of the 19th-century Protestant congregations in the South End to occupy its original building. On July 21, 1982, a serious fire destroyed the main part of the church, including its entire roof. The church dissolved in 1985, and developers converted the building into condominiums.

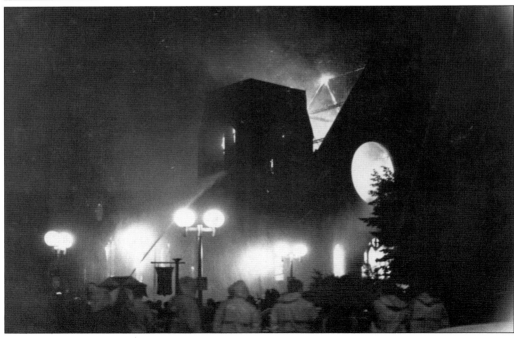

At the corner of Shawmut Avenue and Waltham Street is a brick Greek Revival building, still bearing a sign of the former Sahara Syrian restaurant. Built in 1844–1946 as the Evangelical Lutheran Zion Church, it served the neighborhood's German community. By 1898, the building became too small for their needs and the congregation bought the Church of the Unity on West Newton Street, tearing it down to build the yellow brick building that occupies its site today.

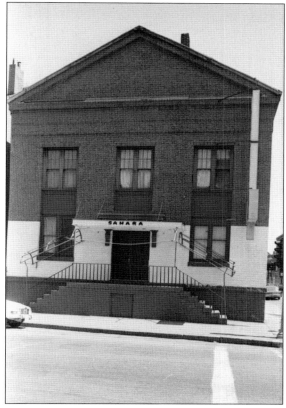

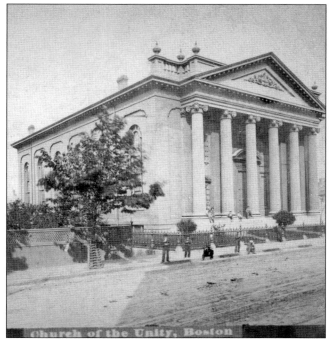

Church of the Unity, Boston

Thomas Silloway designed the Church of the Unity on West Newton Street. He designed the Unitarian church to resemble a Greek temple, yet it was built with brick and wood. The interior featured paintings of Corinthian columns and painted niches with statues. Unfortunately, wood lacks the strength of stone and the church was unstable after 40 years. The Lutherans purchased it in 1898 to construct their new church, also designed by Silloway.

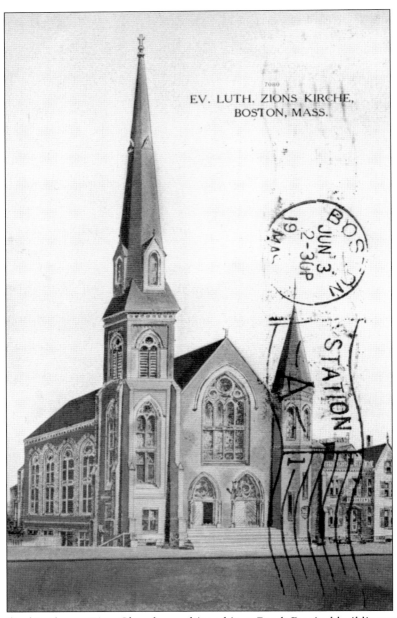

EV. LUTH. ZIONS KIRCHE,
BOSTON, MASS.

The Evangelical Lutheran Zion Church worshipped in a Greek Revival building on Shawmut Avenue in the South End from 1846 to 1898. By 1898, the congregation had outgrown their church and they purchased the old Church of the Unity on West Newton Street. The church demolished the Unitarian church and Thomas Silloway (the same architect that designed the Church of the Unity) designed the new Evangelical Lutheran Zion Church. Interestingly, the congregation conducted services in German until the early 20th century. They remained on West Newton Street until 1956, when the All Saints Lutheran Church purchased the building. The Evangelical Lutheran Zion Church moved to a new building on Marlborough Street. Today, the church is the site of the Jorge Hernandez Cultural Center, which opened in 1986. Renovated in 2003, the Jorge Hernandez Cultural Center is a multiuse venue for the community.

Architect Patrick Charles Keely designed and built the Cathedral of the Holy Cross between 1866 and 1875 on Washington Street. Keely emigrated from Ireland and arrived in New York in 1842. His career soon took off, and Keely designed nearly 600 churches during his lifetime, including 19 churches in Boston.

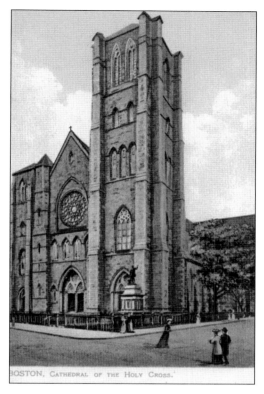

BOSTON, CATHEDRAL OF THE HOLY CROSS.

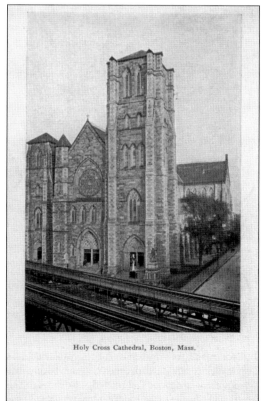

Holy Cross Cathedral, Boston, Mass.

Patrick Charles Keely built the Cathedral of the Holy Cross in the Gothic style with Roxbury puddingstone and Quincy granite. The building is an impressive 364 feet long with a tower that soars to 120 feet. Keely built the arch in the vestibule with bricks saved from the Ursuline convent in Charlestown, which anti-Catholic rioters destroyed in 1834. Today, the church is the largest religious building in Boston.

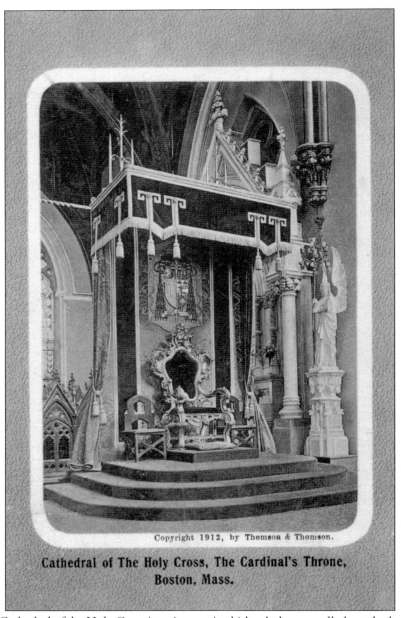

Copyright 1912, by Thomson & Thomson.

Cathedral of The Holy Cross, The Cardinal's Throne, Boston, Mass.

Inside the Cathedral of the Holy Cross is an impressive bishop's throne, called a cathedra, the Latin word for a chair with armrests. The cathedra is traditionally placed in the apse (a semicircular recess covered with a semidome) behind the altar. The method of placing the cathedra in the apse became standard in the Middle Ages. The oldest cathedra still in use today is the Chair of St. Augustine at Canterbury Cathedral in Kent, England. The cathedra pictured here belonged to that of William Henry O'Connell. Born in 1859, O'Connell served as Boston's archbishop from 1907 until his death in 1944. In 1911, O'Connell became the first Boston archbishop to be raised to a cardinal and was given the official title of cardinal-priest of Saint Clement. Cathedrae are typically decorated with the bishop's coat of arms and his motto. Cardinal O'Connell's motto was *vigor in arduis* (strength in difficult times).

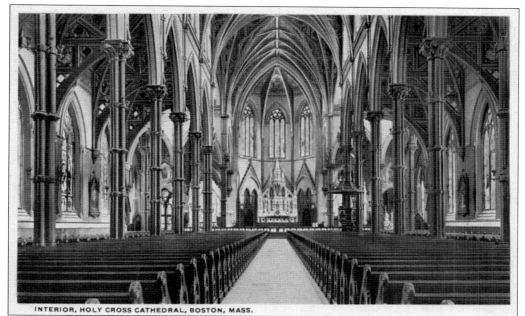

INTERIOR, HOLY CROSS CATHEDRAL, BOSTON, MASS.

Boston pipe organ and manufacturing company E. and G.G. Hook, owned by brothers Elias and George Greenleaf Hook, built the cathedral's organ in 1875. The organ is the largest built by the firm and one of the largest organs in the United States, boasting over 5,000 pipes and 70 stops. The Cathedral of the Holy Cross dedicated the instrument on February 23, 1876, with four of the leading organists in Boston. Architect Patrick Charles Keely designed the organ's Gothic-style case, which is located at the back of the sanctuary. Although still in use, the organ has been undergoing repair since 1986.

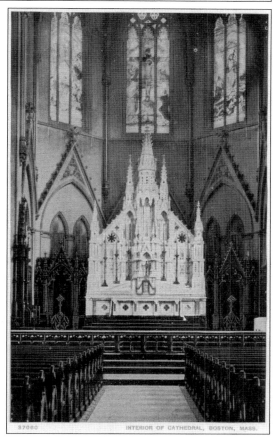

37080 INTERIOR OF CATHEDRAL, BOSTON, MASS.

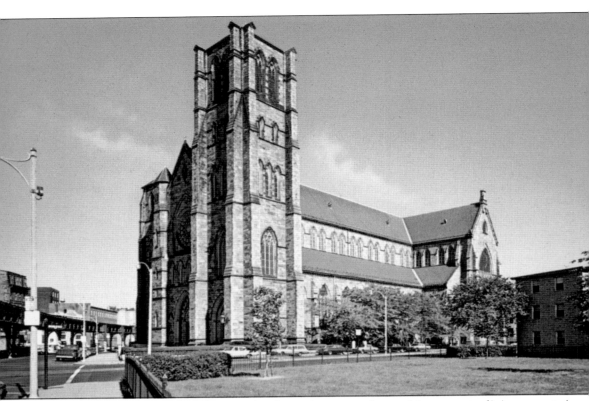

The Cathedral of the Holy Cross has been the scene of several important religious events in Boston. In 1875, the conferral of the pallium on Archbishop John Joseph Williams, Boston's first archbishop, took place at the cathedral. The pallium (an ecclesiastical vestment in the Catholic Church) is reserved for the pope and archbishops. In 1919, the church conducted a high mass celebrated by Cardinal William Henry O'Connell, with King Albert and Queen Louise of Belgium present to thank the United States for its aid during World War I. In 1979, Pope John Paul II visited the Cathedral of the Holy Cross during his first pilgrimage to the United States, where he held a 38-minute prayer service for 2,000 priests in attendance. After the 2013 Boston Marathon bombing, the cathedral held a prayer vigil, with Pres. Barack Obama in attendance.

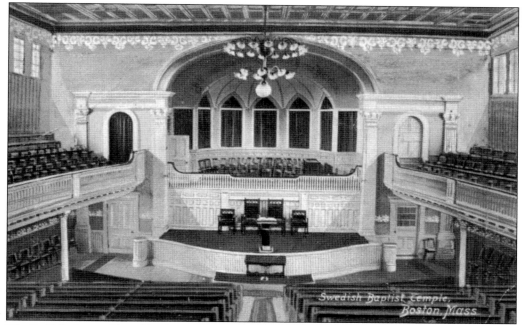

The Suffolk Street Chapel built its church on Shawmut Avenue in 1839 in a mixture of Italianate and Federal Styles. Between 1861 and 1882, the Shawmut Avenue Baptist Church worshipped here, until the congregation moved to the corner of Commonwealth Avenue and Clarendon Street. Pictured here is the interior of the church when the Swedish Baptist Temple owned the building. The congregation worshipped here until 1935.

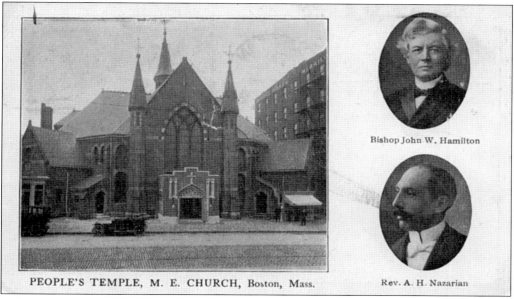

Bishop John William Hamilton founded the People's Church in 1879 as a continuation of the Methodist Episcopal Church on Church Street. John Welch built the church between 1878 and 1884 on the corner of Columbus Avenue and Berkeley Street. It seated 4,000 people and was one of the largest religious structures at the time.

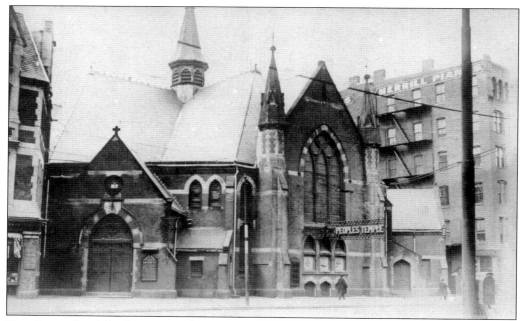

Rev. James Boyd Brady, pastor of People's Church, oversaw an expansion of the building in the 1890s. Brady was born in Ireland in 1845 and immigrated to the United States in 1867. In an attempt to attract members and appear more modern, People's Church changed its name to People's Temple in 1895.

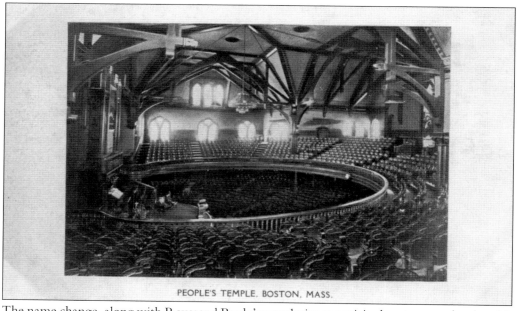

PEOPLE'S TEMPLE, BOSTON, MASS.

The name change, along with Reverend Brady's popularity as a spirited orator, saw the church's membership double to 2,000 from 1895 to 1899. By 1896, newspapers reported that 7,000 to 10,000 people visited People's Temple on a weekly basis, and hundreds of people had to stand at each service due to overcrowding. Unfortunately, this success was short-lived. A year after Brady left People's Temple, membership declined to 364 in 1900.

Financial problems loomed for People's Temple in the 20th century. Members could not provide sufficient contributions and began to serve other neighborhood institutions, such as hospitals and schools. In 1922, the congregation merged with the Tremont Street Methodist Episcopal Church. The city tore down the building and built a parking lot until the construction of the present-day Boston headquarters of the Salvation Army.

PEOPLE'S TEMPLE, Boston, Mass.

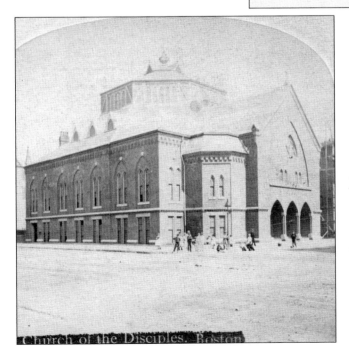

Church of the Disciples. Boston

James Freeman Clarke formed the Church of the Disciples on April 27, 1841. After worshipping in several locations in the city, the congregation built a new church in 1868 on the corner of West Brookline Street and Warren Avenue. The congregation held their first service on Christmas Day 1868 and held an official dedication on February 28, 1869.

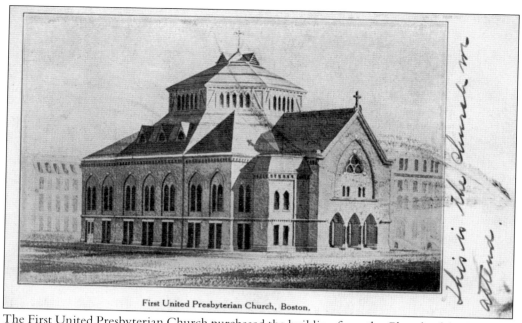

First United Presbyterian Church, Boston.

The First United Presbyterian Church purchased the building from the Church of the Disciples in 1903 and held its first service on November 15, 1903. First United Presbyterian, organized in 1847, is the oldest Presbyterian church in Boston. In 1947, Concord Baptist Church purchased the building. In the 1980s, developers converted the former church into housing.

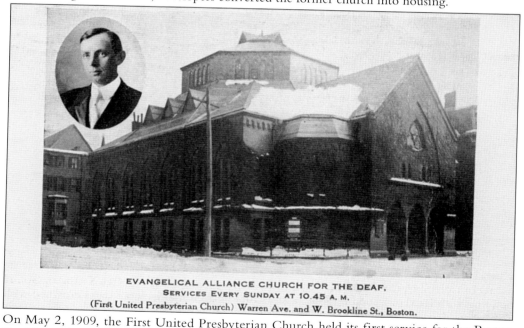

EVANGELICAL ALLIANCE CHURCH FOR THE DEAF.
SERVICES EVERY SUNDAY AT 10.45 A. M.
(First United Presbyterian Church) Warren Ave. and W. Brookline St., Boston.

On May 2, 1909, the First United Presbyterian Church held its first service for the Boston Deaf-Mute Society. Founded in 1877, the organization brought its members together for the first time at the church to worship with a deaf minister. The Evangelical Alliance of Boston hired Rev. E. Clayton Wyand, pictured here, as their pastor, and regularly conducted services on Sunday mornings.

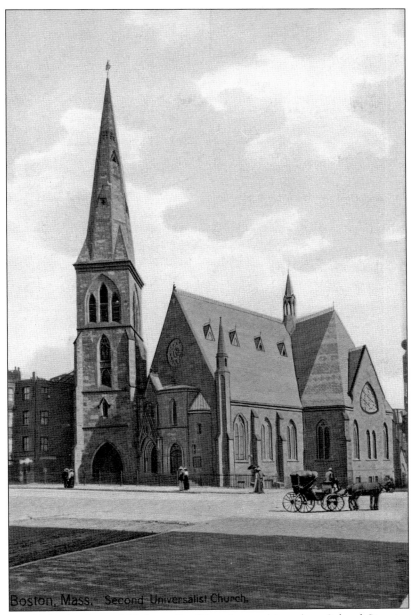

Boston, Mass. Second Universalist Church.

Organized in 1817, the Second Universalist Church worshipped on School Street under Rev. Hosea Ballou. Levi Newcomb designed and built the Second Universalist Church in 1872 at the corner of Columbus Avenue and Clarendon Street. Newcomb built the High Victorian Gothic building with Roxbury puddingstone, and its roof boasted multicolored slates crowned with an iron cresting. Its minister, Rev. Alonzo Ames Miner, was also the second president of Tufts College from 1862 to 1875. On February 10, 1914, a four-alarm fire devastated the church. Although people noticed smoke for hours, it did not alarm anyone until flames broke out. Rev. Stephen Roblin and his congregation temporarily worshipped at the Fenway Theatre until they built a new church in Back Bay. A few years later, Boston College salvaged the stones from the Second Universalist Church to complete the Bapst Library on its Chestnut Hill campus.

Charles E. Parker designed and built the Shawmut Congregational Church on the corner of Tremont and West Brookline Streets in 1863. It was later dedicated on February 11, 1864. Built in a Romanesque Revival style, it featured a large brick tower, belfry and pyramidal roof. The building also boasted a 24-foot rose window at the front and rear of the building.

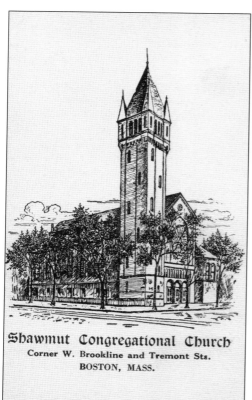

Shawmut Congregational Church
Corner W. Brookline and Tremont Sts.
BOSTON, MASS.

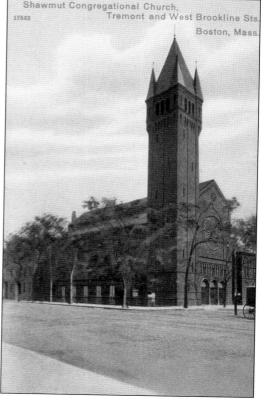

A small fire in 1975 resulted in the destruction of the stained-glass windows on the Tremont Street side of the church. Additional fires over several years culminated in a conflagration in the early morning of December 9, 1978, that destroyed most of the church. A court injunction obtained by the South End Historical Society protected the church from further demolition. A few years later, developers converted the former church into condominiums.

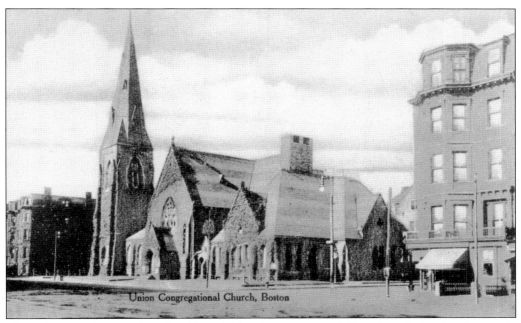

Union Congregational Church, Boston

Alexander Rice Estey designed and built Union Congregational Church on Columbus Avenue in 1870. Like other churches in the South End, Estey built this Gothic-style church with Roxbury puddingstone. Nehemiah Adams served as the congregation's first pastor. He was a vehement supporter of slavery, despite Boston's role in the abolitionist movement.

In 1949, the Union Congregational Church merged with Old South Church and sold the building to the Fourth Methodist Episcopal Church. A predominantly black congregation, they dedicated their first church on May Street in 1824. In 1950, the National Association for the Advancement of Colored People (NAACP) held their national convention at the church. The Union United Methodist Church, formerly the Fourth Methodist Episcopal Church, continues to worship here today.

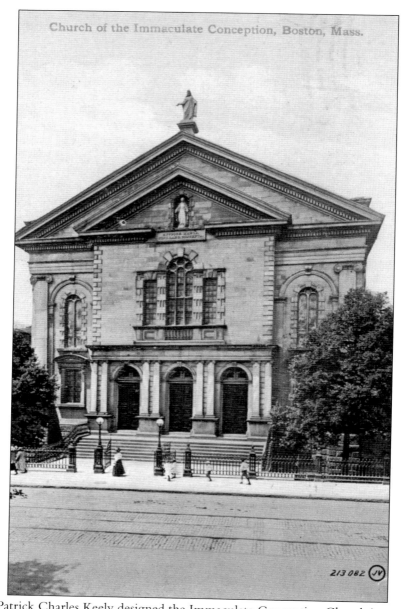

Church of the Immaculate Conception, Boston, Mass.

213 082 JV

Architect Patrick Charles Keely designed the Immaculate Conception Church in a mixture of Georgian, Renaissance, and Classical styles. Over the course of his life, Keely designed nearly 600 churches, many of them in Boston. Keely built the Immaculate Conception Church for the New England Province of the Society of Jesus (Jesuits) on Harrison Avenue, between East Concord and East Newton streets. Ground broke for the church in 1858, and Bishop John Fitzpatrick conducted the dedication on March 10, 1861. In 1987, the Boston Landmarks Commission banned the Immaculate Conception Church from renovating its interior, stating that it had historic and aesthetic importance. The Jesuits sued the Boston Landmarks Commission, and the Massachusetts Supreme Courted ruled in the church's favor. Today, the building is no longer a church and is being renovated into housing. Although deconsecrated, the exterior of the church will remain intact.

This Renaissance Revival–style church, built with white New Hampshire granite, is unlike Keely's other designs. Immaculate Conception's architectural style is probably due to Arthur Gilman. He is credited with designing the interior of the Immaculate Conception Church. The design is similar to Gilman's work on the Arlington Street Church, which is located across from the Public Garden in Boston.

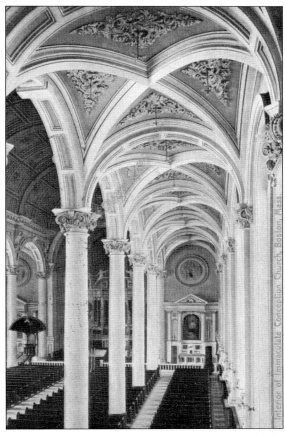

The interior of the Immaculate Conception church boasts a coffered barrel vault and groin-vaulted (or cross-vaulted) aisles. The groin vault was first developed by the Romans, but fell into obscurity until Romanesque architecture emerged in 12th-century Europe. At the back of the sanctuary was a grand organ by Elias and George Greenfield Hook, a Boston pipe organ company.

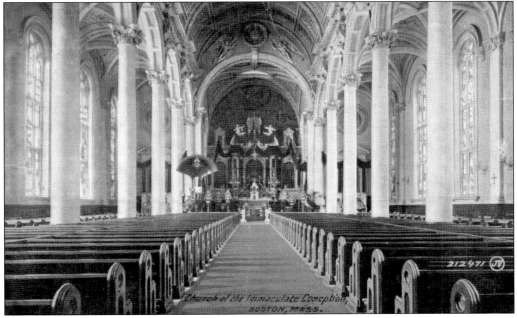

Church of the Immaculate Conception, BOSTON, MASS.

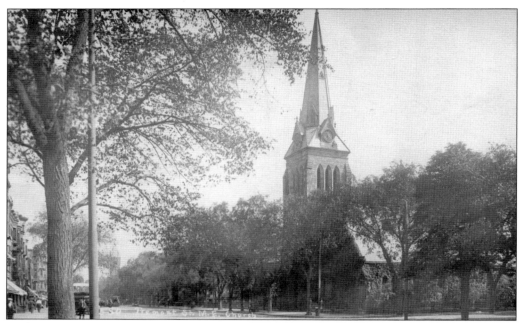

Architect Hammatt Billings designed the Methodist Episcopal Church on Tremont Street in 1862. Akin to other South End churches, it is built with Roxbury puddingstone in the English Gothic style. The church boasts two impressive asymmetrical spires, respectively 150 feet and 100 feet high. The congregation had formerly been on the corner of Shawmut Avenue and Pelham Street in Hedding Church but outgrew the building. The Tremont Street Methodist Episcopal Church continued to worship at 740 Tremont Street until it became the New Hope Baptist Church in the late 1960s. New Hope Baptist worshipped in the building until 2011, when a developer purchased the church.

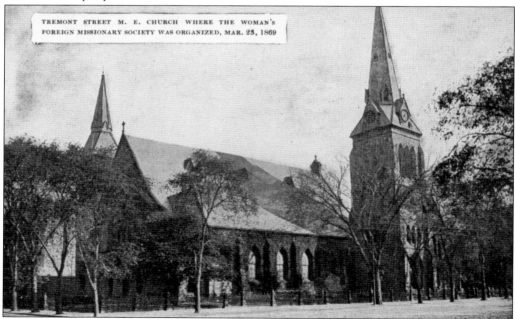

TREMONT STREET M. E. CHURCH WHERE THE WOMAN'S FOREIGN MISSIONARY SOCIETY WAS ORGANIZED, MAR. 23, 1869

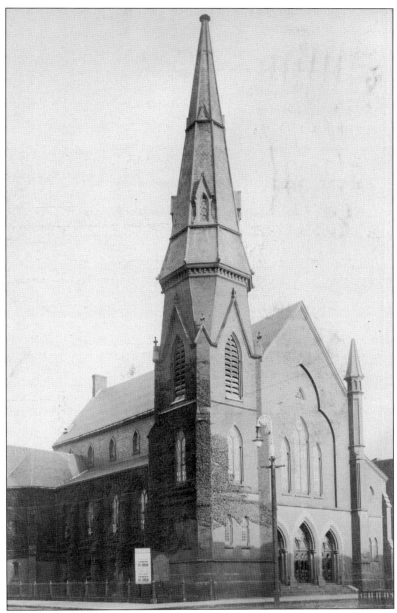

Built in 1856–1866, the Warren Avenue Baptist Church was a Gothic-style building once located on Warren Avenue. Originally the Second Baptist Church, the congregation formed in 1743 after becoming dissatisfied with the teachings of Rev. Jeremiah Condy of the First Baptist Church. The congregation worshipped at Baldwin Place in Boston's North End until they built a new church in the South End. In 1875, the Warren Avenue Baptist Church was the site of a murder. On May 23, the church's sexton Tom Piper lured five-year-old Mabel Young up to the belfry to look at pigeons and crushed her skull with a cricket bat. She was still alive when found but died the following night. Piper escaped but was later arrested and tried for the murder of Young. On May 7, 1876, Piper finally confessed to the murder and several others. Authorities hanged Piper on May 26, 1876, at the Suffolk County Jail in front of a crowd of 400 people.

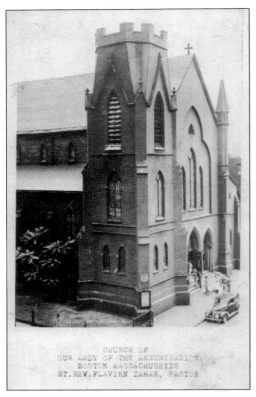

CHURCH OF
OUR LADY OF THE ANNUNCIATION,
BOSTON MASSACHUSETTS
RT. REV. FLAVIEN ZAHAR, PASTOR

Around 1942, the Warren Avenue Baptist Church became home to the Church of Our Lady of the Annunciation, a Syrian Roman Catholic parish. After 25 years, the congregation moved out of Boston, and the building remained vacant until a fire destroyed the building in 1967. Residents were successful in turning the lot into James Hayes Park, named after the head of a beloved South End family.

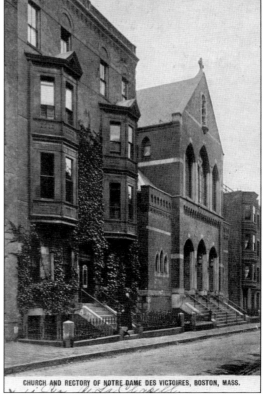

CHURCH AND RECTORY OF NOTRE DAME DES VICTOIRES, BOSTON, MASS.

Known today as Our Lady of Victories, Notre Dame des Victoires was Boston's first French parish. In contrast to other immigrant groups, it was not until 1880 that there were enough French-speaking residents in Boston to support their own church. Since its establishment, the Marist Fathers ran the church. The Marist Fathers is a religious society founded by Rev. Jean-Claude Colin in 1816.

The Marist Fathers purchased a site on Isabella Street in 1885 for Notre Dame des Victoires. The church opened in 1892 for the public. The redbrick church is a mixture of Gothic and French Renaissance styles. Although located in Back Bay, Notre Dame des Victoires has served scores of French Canadian South End residents over the years. By the turn of the 20th century, Notre Dame des Victoires served a congregation of over 10,000 people. After a shrinking congregation, lack of funds, and the withdrawal of the Marist Fathers, the church permanently closed in 2016. A local developer recently purchased the church and will convert it into housing.

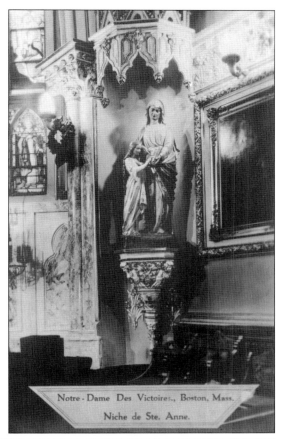

Notre-Dame Des Victoires., Boston, Mass.
Niche de Ste. Anne.

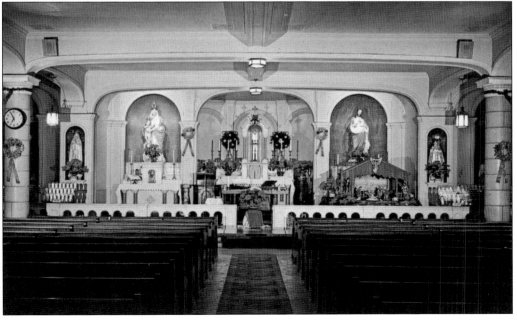

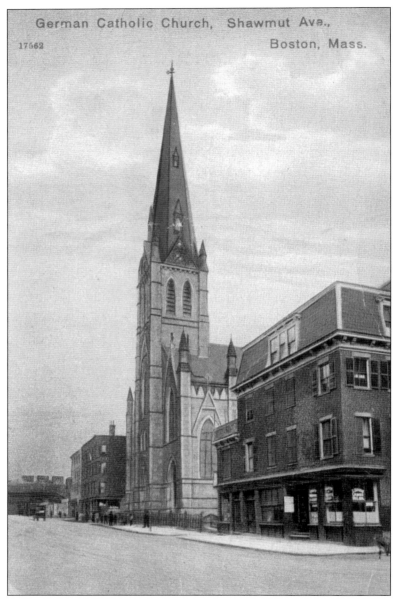

German Catholic Church, Shawmut Ave.,

17562

Boston, Mass.

Located four blocks from the Cathedral of the Holy Cross is the Holy Trinity German Catholic Church. The congregation originated with three German Catholic brothers: Melchior, Sebastian, and Mathias Krämer, who settled in Boston in 1827. After outgrowing the original Holy Trinity Church, the congregation purchased a site on Shawmut Avenue for a new church. The cornerstone was laid on November 10, 1872, and dedicated on May 27, 1877. Irish architect Patrick Charles Keely designed the Catholic church, like many others in the neighborhood. He built the Gothic-style church with Roxbury puddingstone and Maine granite. The church's large steeple soared above the city's skyline until a hurricane in 1938 damaged it beyond repair. The Holy Trinity Catholic Church is credited with introducing the Christmas tree, Christmas greeting cards, and the Christmas pageant to the United States. The first Christmas pageant took place here in 1851.

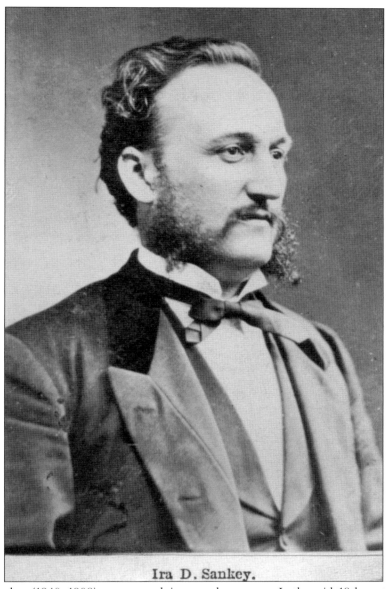

Ira D. Sankey.

Ira David Sankey (1840–1908) was a gospel singer and composer. In the mid-19th century, Sankey became well known as a gospel singer and crossed paths with evangelist Dwight L. Moody in 1870. The two soon began traveling together to revival meetings in the United Kingdom. In 1876, a large, temporary structure was built on Tremont Street in the South End where the Boston Center for the Arts is today. Moody raised a considerable amount of money to build the structure, known as Moody's Tabernacle. The elaborate building, although temporary, was constructed with brick and pine timber. With a seating capacity of 6,000 people, this building would house the 13-week revival led by Dwight Moody. Dr. Eben Tourjée, founder of the New England Conservatory of Music, led a 2,000-person choir, and Ira Sankey sang. Over 13 weeks, Moody preached over 100 sermons, Sankey sang over 300 solos, and purportedly, over one million people (many repeat attendees) entered the doors of Moody's Tabernacle to hear his sermons.

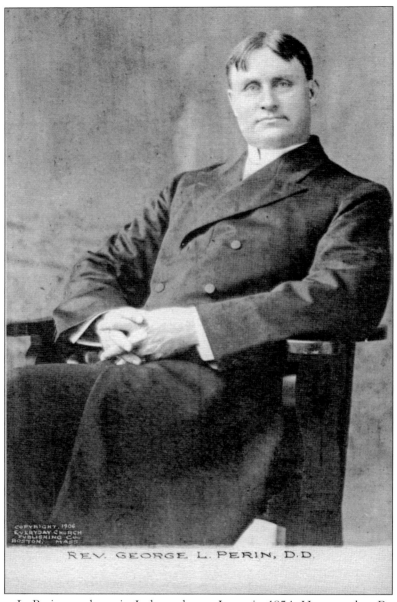

REV. GEORGE L. PERIN, D.D.

Rev. George L. Perin was born in Independence, Iowa, in 1854. He moved to Boston in the 1880s to become pastor of the Shawmut Universalist Church. In 1890, the Universalists sent Perin to Japan as a missionary. During his four years in Japan, Perin founded a theological school, Universalist magazine, and five branch missions. He returned to Boston in 1894 and agreed to become pastor of the Shawmut Universalist Church once again, under the condition that it become an institutional church. In the 1890s, the South End shifted from an upper-middle class residential neighborhood to a working-class and diverse immigrant enclave. Perin wanted the church to meet the needs of the neighborhood and provide social services to the poor. In 1902, Perin recognized the need for affordable and safe housing for young single women in Boston and founded the Franklin Square House for Women in the former St. James Hotel. Perin continued to serve the South End community as a pastor and philanthropist until his death in 1922.

Four

SERVING THE COMMUNITY

The allure of the newly built Back Bay neighborhood and a recession in the late 19th century saw the South End shift from a largely middle-class and upper-middle-class neighborhood to a diverse working-class community. By the end of the 19th century, single-family row houses gave way to tenement and lodging houses. The South End was not the poorest neighborhood in Boston, but it still had its share of those in need. Without a safety net, unemployment could mean eviction or starvation. One thing was certain, and that was the South End's commitment to social services.

Many institutions stepped up to assist the neighborhood's neediest residents. Most were religious institutions, such as the Union Rescue Mission. In addition, several churches during this time became known as "institutional churches." These churches needed to provide more than Sunday sermons to the community; they needed to help those in need through programs and social services. The most notable, perhaps, is Morgan Memorial Goodwill Industries. Henry Morgan founded Morgan Chapel in 1861, but it was in 1895 when Edward Helms took charge that a relatively small church transformed into a global institution that continues to assist millions of people annually.

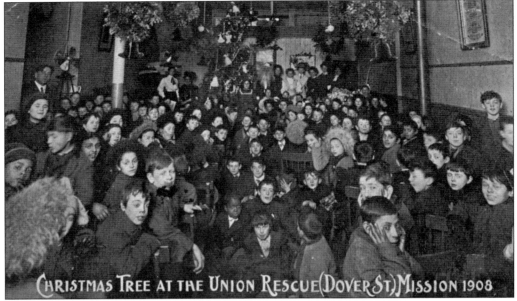

CHRISTMAS TREE AT THE UNION RESCUE (DOVER ST.) MISSION 1908

William H. West founded the Union Rescue Mission in 1890, and it was originally located on Kneeland Street before moving to Dover Street (now East Berkeley Street). The Union Rescue Mission's aim was to help alcoholics and residents in need of help. The mission was open daily, offering advice and a reading room to the public. The Union Rescue Mission would conduct a 5:00 p.m. service every day and serve free dinner every Wednesday and Sunday evening.

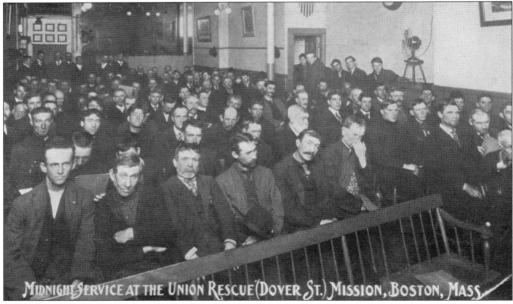

MIDNIGHT SERVICE AT THE UNION RESCUE (DOVER ST.) MISSION, BOSTON, MASS.

The Union Rescue Mission would hold daily meetings for the public. Meetings would usually consist of singing hymns, hearing lectures on the power of Jesus, readings from the Bible, and personal testimonies from attendees. Afterwards, the mission gave those in need a meal ticket and lodging for one night. From Christmas until New Year's Day, the Union Rescue Mission would provide free midnight meals for men.

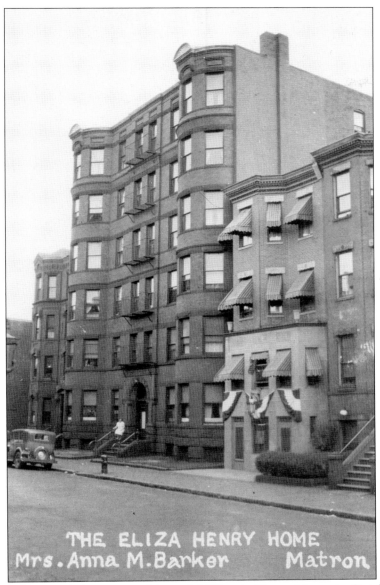

THE ELIZA HENRY HOME
Mrs. Anna M. Barker Matron

Eliza A. Henry founded the Morgan Memorial Eliza A. Henry Home in October 1926 for elderly working women and married students. Eliza and her sons, George and John Henry, were Morgan Memorial's biggest benefactors. Edward Helms became acquainted with the Henry family in 1912, and they immediately invested $100,000 in building a factory adjacent to Morgan Chapel. George Henry was actively involved with Morgan Memorial and served on its board of directors. When he died, George Henry had donated $350,000 (approximately $4.9 million today) to Morgan Memorial. Eliza A. Henry was 94 years old when Morgan Memorial dedicated the Eliza A. Henry home in October 1926. Located at 17 Yarmouth Street, the building was originally a family hotel for Judge H.S. Dewey. The Eliza A. Henry Home was for elderly women and young married students. It was not a nursing home, and its residents worked for Morgan Memorial to earn their room and board. When the elderly women could no longer pay and care for themselves, they found accommodation elsewhere.

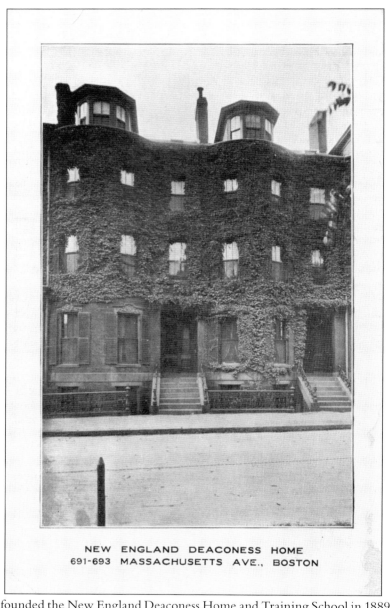

NEW ENGLAND DEACONESS HOME
691-693 MASSACHUSETTS AVE., BOSTON

Methodists founded the New England Deaconess Home and Training School in 1889 in Boston. Its mission was to train women in urban and foreign missionary work, as well nurses' training. Germany revived the deaconess movement in 1836 when Lutheran minister Theodor Fliedner opened the first deaconess home in Düsseldorf. The deaconess movement quickly spread throughout Europe and the United States. Unlike deacons, deaconesses were not ordained, and they studied at the New England Deaconess Home and Training School for several years to prepare them for careers in missionary work. In 1918, Boston University absorbed the New England Deaconess Home and Training School, and it became the university's Department of Social Work. The New England Deaconess Home and Training School led to the founding of the New England Deaconess Hospital, a 14–bed infirmary located at 691 Massachusetts Avenue. The hospital later merged with Beth Israel Hospital to form Beth Israel Deaconess Medical Center.

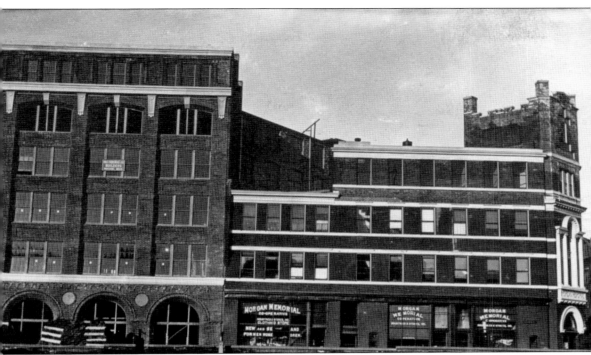

Edgar James Helms, a graduate of Boston University Theological School, took over Morgan Memorial in 1895 and was appalled by the conditions faced by South End residents, many of whom were unemployed immigrants. Helms offered a self-supporting method of relief for residents, rather than charity. It began with Morgan Memorial's relief bags, which the church distributed throughout the richer districts in Boston, asking families to donate any clothing and other items they no longer wanted. Workers brought these items back to Morgan Memorial where they would clean, repair, and resell items in the department store on the ground floor. Morgan Memorial thrived under Helms and evolved into Morgan Memorial Goodwill Industries. The institution had three main buildings: the Children's Settlement, the Fred H. Seavey Seminary Settlement, and an industrial building. By 1920, there were 15 Goodwill buildings in the United States.

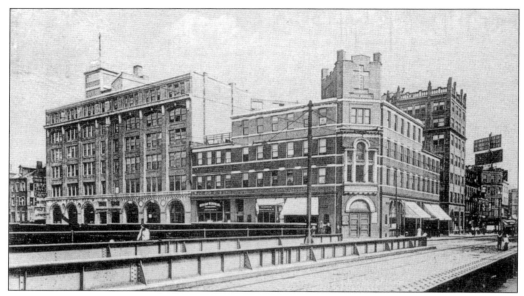

Morgan Memorial is synonymous with Edgar Helms, but it was actually founded by Methodist minister Henry Morgan. Arriving in Boston in 1859, he founded Morgan Chapel in 1861. It was after Morgan died that the church thrived under Edgar James Helms and evolved into Morgan Memorial Goodwill Industries. The church was unique in that it was more than a church; it was also a social center, rescue mission, industrial facility, and children's settlement.

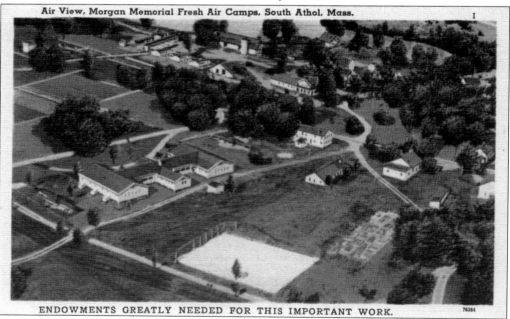

Air View, Morgan Memorial Fresh Air Camps, South Athol, Mass.

ENDOWMENTS GREATLY NEEDED FOR THIS IMPORTANT WORK.

Morgan Memorial's philanthropy extended 80 miles west of Boston in the small town of Athol, Massachusetts. Here, Morgan Memorial established a farm which offered more opportunities for adults and children. On the farm in South Athol, one found a rug factory, a church, and several open-air camps for children. The camps accommodated 150 South End children for two months during the summer.

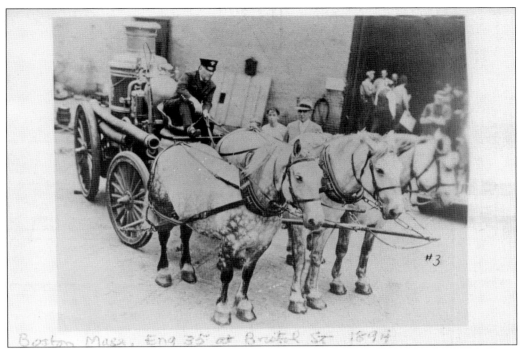

Boston, Mass., Eng 35 at Bristol St 1894

The Bristol Street Fire Station was the former headquarters of the Boston Fire Department. The great Boston Fire of 1872 was the city's largest urban fire and took two days to control, ultimately destroying 776 buildings. Incredibly, there were only 13 casualties. To prevent another disastrous fire, Boston built a new firehouse with an observation tower.

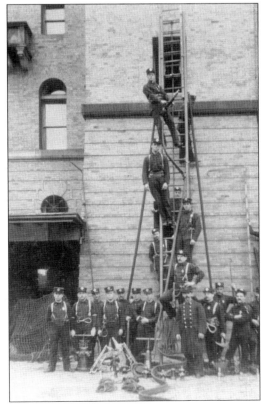

Noted architect Edmund Wheelwright, also responsible for Horticultural Hall and the Longfellow Bridge, designed the fire station. Built between 1892 and 1894, Wheelwright modeled the Renaissance Italian–style tower after the Palazzo Vecchio in Florence, Italy. Florentine towers became a popular design for fire stations in the United States. The postcard shows the fire department training its men in firefighting high–rise techniques.

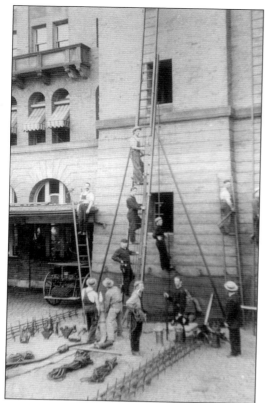

In 1961, headquarters for the Boston Fire Department moved to Southampton Street in Roxbury. The yellow brick building on Bristol Street (now Paul Sullivan Way) remained vacant until 1980, when the Pine Street Inn moved in. Today, this unique building is still the location of the Pine Street Inn, a nonprofit organization that provides meals, shelter, and services to the city's homeless.

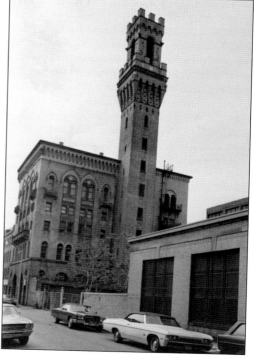

The Pine Street Inn, established in 1969 on Pine Street in Chinatown, offered shelter and coffee for 200 men. In the 1980s, the Pine Street Inn outgrew its original facility and moved to the former Boston Fire Department Headquarters on Harrison Avenue. Today, it provides shelter, housing, outreach, and job training to 1,600 men and women per day. The organization's goal is to make permanent housing a possibility for all people.

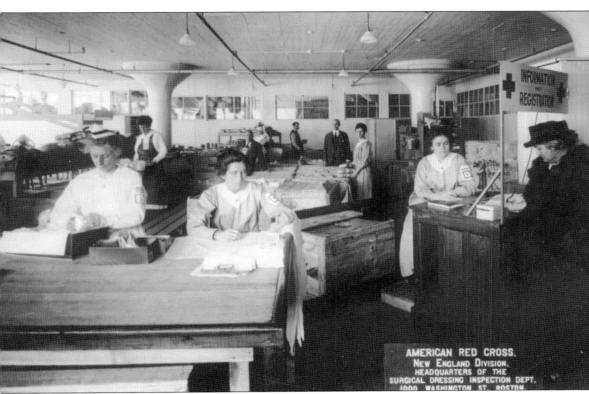

AMERICAN RED CROSS.
NEW ENGLAND DIVISION.
HEADQUARTERS OF THE
SURGICAL DRESSING INSPECTION DEPT.
1000 WASHINGTON ST. BOSTON.

When the United States entered World War I in 1917, the American Red Cross organized a supply service. The American Red Cross supply service headquarters were located in Washington, DC, with local branches spread across the United States. The Red Cross established Boston's branch at 1000 Washington Street, under the direction of businessman Henry S. Dennison. The supply service collected medical supplies and goods and sent them overseas at the direction of the War and Navy Departments. Pictured here is the Surgical Dressings Inspection Department. The workers, many of them women, inspected medical supplies before the Red Cross sent it overseas. Clara Barton established the American Red Cross in 1881 after traveling in Geneva, Switzerland, after the Civil War. Prior to World War I, the American Red Cross was a small organization with limited funds and staff. The onset of World War I transformed the American Red Cross from a small organization to a global institution. Membership expanded from 17,000 in 1914 to over 20 million adult members and 11 million junior members in 1918.

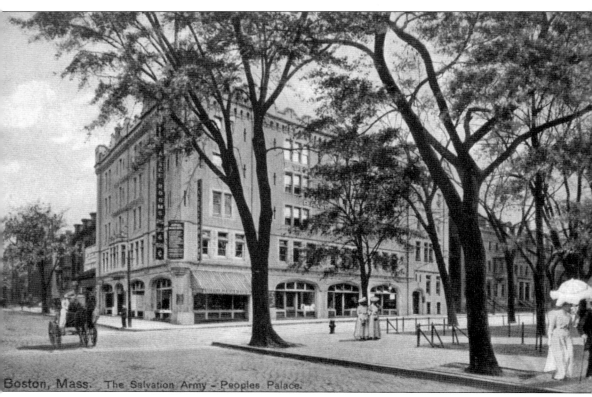

Boston, Mass. The Salvation Army - Peoples Palace.

Gen. William and Catherine Booth founded the Salvation Army in London in 1865 as the East London Christian Mission. The organization adopted the name Salvation Army shortly afterwards. The organization found its way to Boston in 1884 and established its New England headquarters at 8 East Brookline Street, pictured here. Known as People's Palace, it was located across from Franklin Square and was a large, affordable hotel for men. At People's Palace, one found 287 rooms, a library, sitting and smoking rooms, a gymnasium, pool, dining room, and auditorium. A number of the hotel's guests were men who lived outside of the city and worked in Boston, such as firefighters and railroad workers. The Boston Housing Authority demolished People's Palace in 1948 to make way for the Cathedral Housing Veterans Project, which housed World War II veterans and their families.

Pictured here is the Massachusetts branch of the Woman's Christian Temperance Union, located in Chester Square at 541 Massachusetts Avenue. A group of women, concerned by the destructive power of alcohol, founded the Woman's Christian Temperance Union in 1874 in Cleveland, Ohio. This active temperance organization is one of the oldest women's organizations devoted to social reform in the world. When founded, the organization's mission was to create a "sober and pure world" through abstinence, purity and Christianity. The Woman's Christian Temperance Union, although closely associated with the temperance movement and the 18th Amendment, became involved in numerous social reform issues such as labor, public health, prostitution, and world peace. Although an international organization, the Woman's Christian Temperance Union did not accept members who were Catholic, Jewish, African American, or foreign-born for several years. Today, the building is the location of the Mt. Calvary Baptist Church.

On March 23, 1869, eight women met at the Tremont Street Methodist Episcopal Church at the urgent call of Clementina Butler and Lois Parker. Wives of missionaries, they noticed the lack of women's health care while in India. The meeting culminated in the formation of the Woman's Foreign Missionary Society. Pictured here is the home of Maria Rich, where the organization held its first general executive meeting on April 20, 1870.

HOME OF MRS. THOMAS A. RICH, 706 TREMONT STREET WHERE THE 1st GENERAL EXECUTIVE MEETING WAS HELD, APRIL 20, 1870

Clementina Butler, Lois Parker, and others founded the organization despite opposition from the Missionary Society of the Methodist Episcopal Church in New York. The Tremont Street Methodist Episcopal Church incorporated the names of the eight founding members in a memorial window, located at the back of the sanctuary. The church unveiled the window on the 20th anniversary of the Woman's Foreign Missionary Society, with seven of the eight founders present.

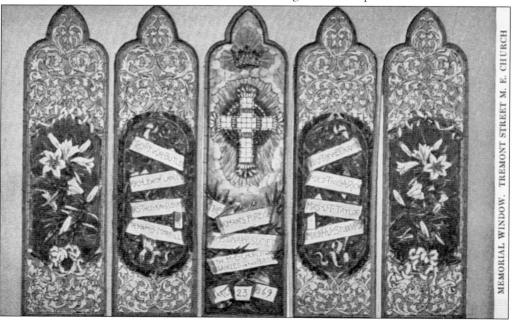

MEMORIAL WINDOW, TREMONT STREET M. E. CHURCH

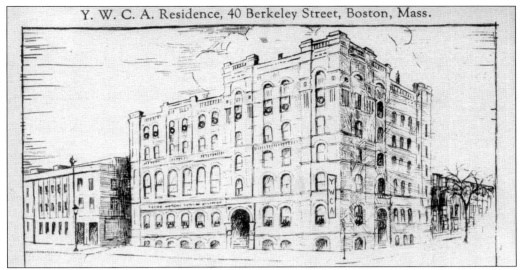

Pauline Durant established the Young Women's Christian Association (YWCA) in 1866 with several friends because they wanted to improve the conditions that self-supporting women in the city dealt had to deal with. The YWCA at 40 Berkeley Street opened in December 1884 and was the first YWCA and residence in the United States, which provided housing for young working women and students in Boston.

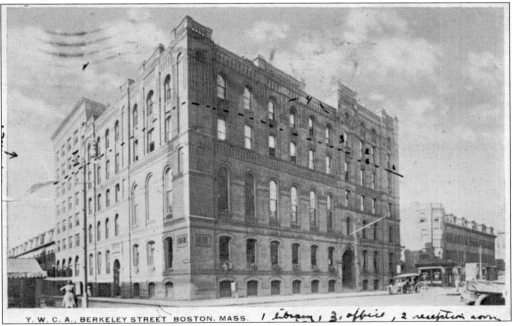

Y. W. C. A., BERKELEY STREET BOSTON. MASS. 1 library, 3, office, 2 reception room

The YWCA provided more than accommodation for young women. The building at 40 Berkeley Street housed the training school, employment bureau, educational departments, administration offices, gymnasium, and a reading room. Additionally, in 1887 the organization founded the Travelers' Aid Department. YWCA employees would meet newly arrived women in Boston at the docks and provide everything from protection, to finding friends and family, to lodging and employment.

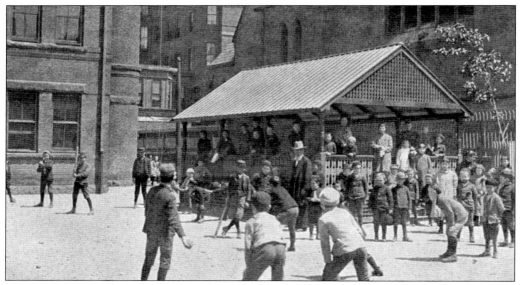

A group of Boston businessmen founded the New England Home for Little Wanderers in May 1865 as a private charity to care for orphaned children left homeless by the Civil War. Originally located in Baldwin Place in the North End, the organization built a new facility at 202 West Newton Street for $125,000 in 1889. The picture shows a group of children playing baseball outside the home in 1894.

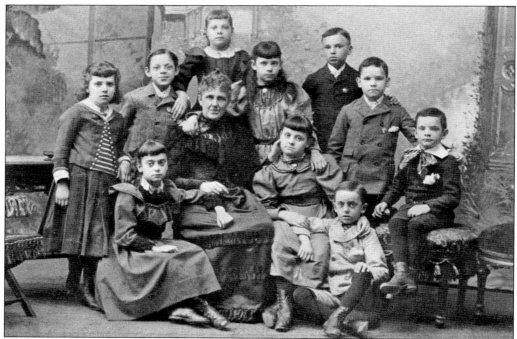

The New England Home for Little Wanderers was a temporary home for orphaned children, until they were adopted or placed with family members. Pictured here is Mrs. C.H. Minor with her music students in 1894. In 1914, the organization sold the building on West Newton (now Titus Sparrow Park) and built a new facility on South Huntington Avenue.

Five

EDUCATION
AND TRAINING

To meet the needs of residents and their families, numerous schools emerged in the neighborhood in the 19th century. These schools ranged from elementary schools, to private institutions, and even several colleges. The architectural style of most school buildings differed from a typical South End row house, although some schools were actually located in a brick row house, such as the Trade School for Girls on Massachusetts Avenue. One of the most impressive buildings for children in the South End was English High and Boston Latin Schools. The two schools shared a building on a block bounded by Warren Avenue and Dartmouth, Montgomery, and Clarendon Streets.

Today, the South End has only five primary and secondary schools in the neighborhood. Several of the former school buildings in the South End have been preserved and converted into housing, such as the former Rice School on Appleton Street. Of all the schools mentioned in this chapter, the only one that remains in the South End today is the Ben Franklin Institute of Technology, founded in 1908 from a portion of Benjamin Franklin's will.

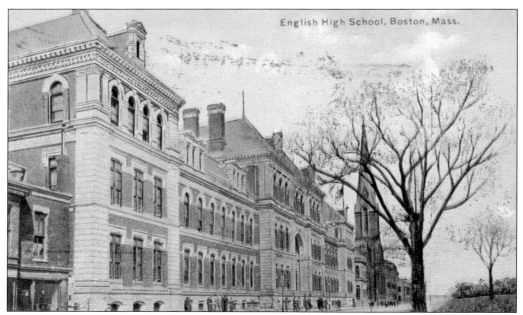

The Boston School Committee established English High School in 1821 as a school for working-class boys, to prepare them for jobs in business, mechanics, and engineering. Originally named the English Classical School, its first location was on Derne Street near the Massachusetts State House. The school found its way to the South End in 1881 at its fourth location.

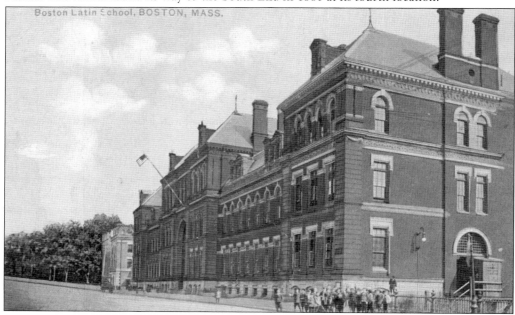

Boston Latin School, established in 1635, holds the distinction of being the oldest school and the first public school in the United States. The school modeled itself around the European Latin School with a curriculum focused on Latin, classical literature, and religion. Although a public school, Boston Latin was originally intended for Boston's wealthy families and prepared students for college.

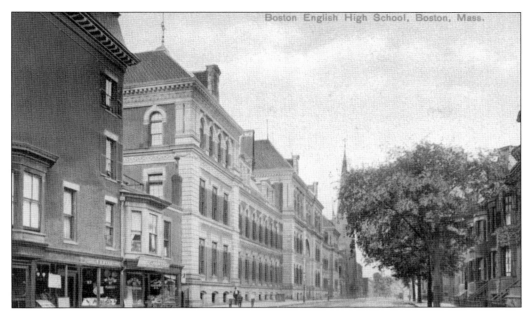

English High School and Boston Latin School moved to the South End in 1881, occupying the block bounded by Warren Avenue and Dartmouth, Montgomery, and Clarendon Streets. City architect George A. Clough designed the building in 1877. The large building housed both schools with connecting facilities and separate entrances. English High School faced Montgomery Street, while Boston Latin School faced Warren Avenue.

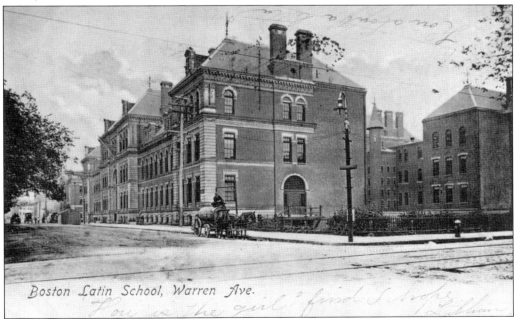

Boston Latin School, Warren Ave.

Since 1887, English High and Boston Latin Schools have played football on Thanksgiving. The two schools have the oldest continuing high school rivalry in the United States. They shared the building until 1922, when Boston Latin School moved from the South End to its current location at 78 Avenue Louis Pasteur.

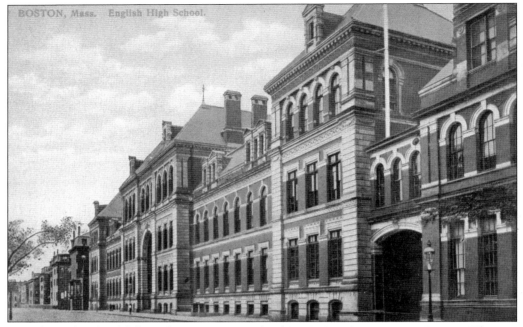

English High School followed Boston Latin School in 1954 to Avenue Louis Pasteur. The two schools remained across the street from each other until English High School moved once again in 1989. The location is now part of Harvard Medical School. Today, English High School is in Jamaica Plain, Boston.

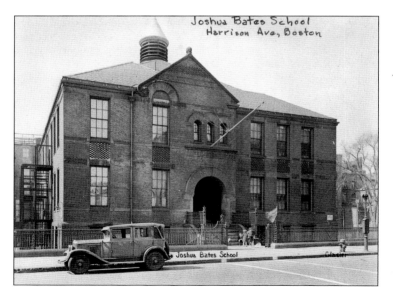

Joshua Bates School
Harrison Ave, Boston

Joshua Bates School

Arthur H. Vinal designed and built the Joshua Bates School in 1884 at 731 Harrison Avenue. Vinal built the school with brick in the Romanesque Revival style. The City of Boston named the school after Joshua Bates, an international financier and benefactor of the Boston Public Library. After closing in 1975, the school is now the Bates Art Center. (Boston City Archives.)

The Trade School for Girls, established in 1904 with 14 students, was originally located at 674 Massachusetts Avenue. The organization's aim was to train young women in nondomestic trade, allow them to enter the work force at higher wages, and to become self-supporting and independent. The school taught young women a variety of skills, such as dressmaking, millinery (hat making), embroidery, catering, and box making. In 1909, the Boston School Committee incorporated the Trade School for Girls into the Boston School System, making it the first state-funded industrial school for women. After becoming incorporated into the Boston School System, the school moved to 618–620 Massachusetts Avenue in the former Sacred Heart Academy. Pictured here is the 1914 class for the Trade School for Girls. Today, these buildings are no longer in existence, and it is now the site of a Dunkin Donuts parking lot.

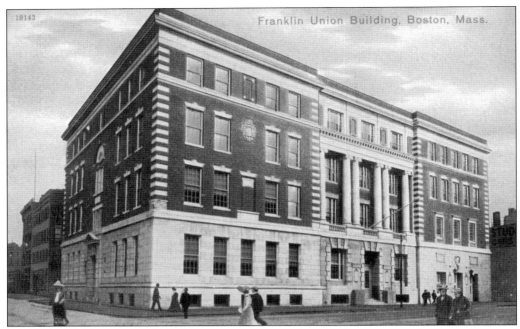

Founded in 1908, the Benjamin Franklin Institute of Technology is one of oldest colleges of technology in New England. In Benjamin Franklin's will, dated 1789, he left £2,000 to be divided equally between Philadelphia and Boston for the use of young apprentices. After 100 years, part of the money could be disbursed and the remainder given out a century later. The money Benjamin Franklin bequeathed to Boston and Philadelphia came from his salary as governor of Pennsylvania from 1785 to 1788. After 100 years had passed, Boston decided to use the money to establish a technical school in his name. With the help of Andrew Carnegie and land donated by Boston, the institute opened in 1908.

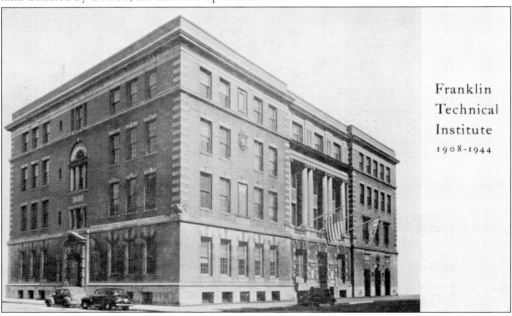

Franklin
Technical
Institute
1908-1944

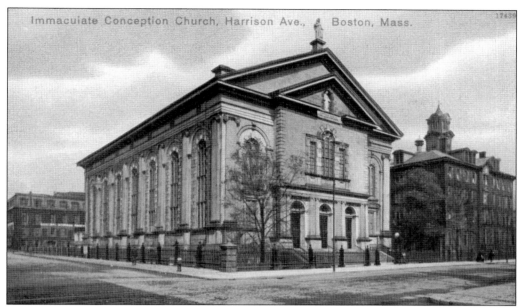

Located to the right of Immaculate Conception Church is the original building of Boston College. Lois Weissbein designed the four-story brick building topped with a cupola. John McElroy recognized the need for a Jesuit college and raised funds in 1857. Two years later, Boston College opened on Harrison Avenue as the second Jesuit institution of higher learning in Massachusetts. The college briefly closed for two years due to the outbreak of the Civil War and financial issues. Boston College shared its South End campus with Boston College High School until the 20th century. College president Thomas Gasson purchased Amos Adams Lawrence's farm in Chestnut Hill, located six miles away. In 1913, the college moved to its new campus where it resides today.

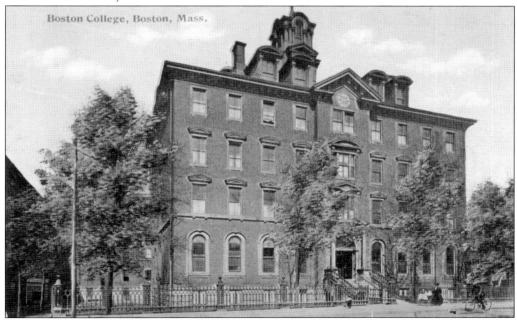

Boston College, Boston, Mass.

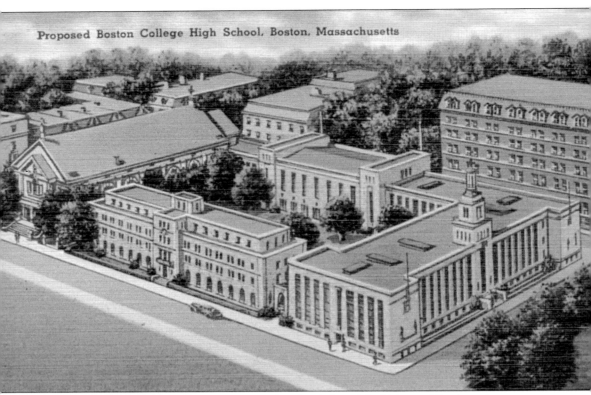

Proposed Boston College High School, Boston, Massachusetts

Boston College and Boston College High School shared facilities on Harrison Avenue next to the Immaculate Conception Church for several years before the school became cramped. By 1913, the building accommodated 1,300 high school and college students. Boston College moved that same year to Chestnut Hill, while Boston College High School continued on Harrison Avenue. Despite the split, both schools shared an administration until 1927, when they officially became two institutions. In the 1940s, Boston College High School proposed to raze the current buildings on Harrison Avenue and build new facilities on the site. The school abandoned its plan when they realized they would not be able to build athletic fields for its students next to the school. In 1948, Boston College High School purchased over 70 acres of land on Columbia Point in Dorchester for a new campus. The school opened two years later in 1950 for juniors and seniors, with the rest of the student body moving to Columbia Point in 1954.

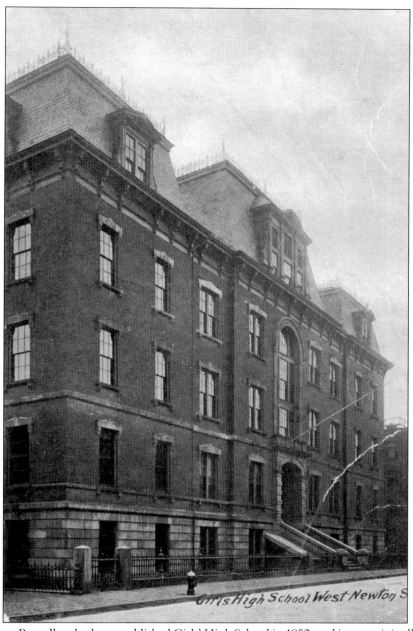

Girls High School West Newton S

Dr. LeBaron Russell and others established Girls' High School in 1852, and it was originally located in the old Adams school on Mason Street above a public library. Quickly outgrowing the facility, the city built a new school in 1869 on West Newton Street in the South End. The new school was officially dedicated on April 9, 1871. The redbrick school, occupying over 30,000 square feet, was the largest in New England at the time. In 1878, Girls' High School shared the building with the newly established Girls' Latin School (today known as Boston Latin Academy), the first college preparatory high school for girls in the United States. The building was insufficient for two schools, but Girls' Latin School remained until 1907. The city razed the building on West Newton Street in 1960, and today, it is the site of the Thomas F. O'Day playground.

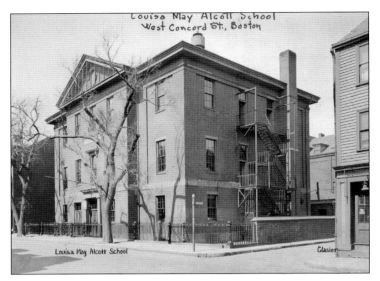

The short-lived Louisa May Alcott School was located at 109 West Concord Street between 1910 and 1961. The school is named after author and poet Louisa May Alcott, who briefly lived in the South End, both with her parents and on her own. The school closed in 1961, and today, the location is residential housing. (Boston City Archives.)

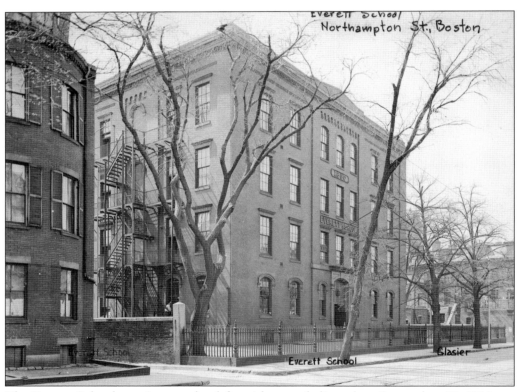

The Everett School, a primary school for girls, was dedicated on September 17, 1860, on Northampton Street. The City of Boston named the school after Edward Everett, a distinguished orator and politician, who served as a US representative, senator, secretary of state, and as the president of Harvard University. In 1965, a fire damaged the school and the Boston School Committee decided to demolish the building rather than repair it. (Boston City Archives.)

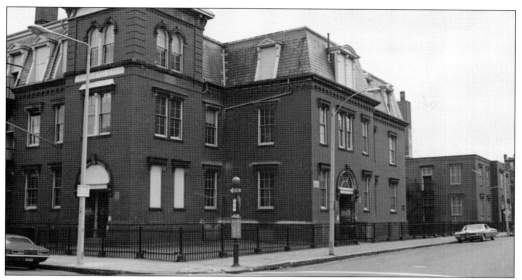

Architects William Ralph Emerson and Carl Fehmer designed the Rice School in the 1860s and it opened on September 23, 1869. The City of Boston named the school after South End resident Alexander H. Rice, who served as mayor of Boston, a congressman during the Civil War, and 30th governor of Massachusetts. The Rice School operated as a public school until 1981, and developers converted the former school into housing in 1985.

The Bancroft School operated in the former Rice School on Appleton Street. It was an experimental elementary school whose curriculum utilized active parent participation and community resources to give its students a diverse and well-rounded education. The Boston School Committee fought to close the school in the 1970s during the desegregation of Boston public schools, despite the fact that the school was racially integrated. The school later closed in 1981.

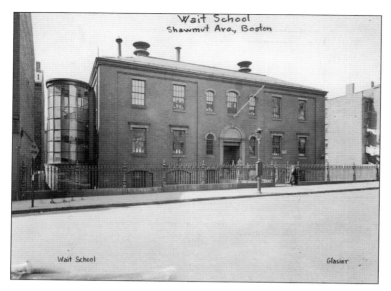

The Wait School, established in 1860, was located at 125 Shawmut Avenue, across from Holy Trinity Church. Noted architect Gridley F. Bryant designed the elementary school. Bryant was also responsible for designing Boston City Hospital, the Deacon House, the Hurley School, and the old Boston City Hall on School Street. (Boston City Archives.)

The John J. Williams School was located on Groton Street. Formerly the Cook School, the City of Boston renamed it the John J. Williams School in 1913 after Bishop John Joseph Williams, who served as Boston's first archbishop from 1866 to 1907. (Boston City Archives.)

Six

ACCOMMODATION AND ENTERTAINMENT

Along with the residential construction of the 1850s and 1860s came the establishment of hotels, theaters, and other public institutions. By the late 19th century, single-family homes gave way to tenement and lodging houses. During this time, many of the hotels found in the South End were known as "apartment hotels." These buildings provided long-term accommodations for families who lived in the neighborhood. Most of these hotels were located on three major streets in the South End: Columbus Avenue and Washington and Tremont Streets. Columbus Avenue took a bit longer than other parts of the South End to develop and was a cheaper area to live.

Besides its ample accommodations, the South End was a popular neighborhood for entertainment. It was home to several theaters, such as Castle Square and Columbia theaters, as well as a baseball field. John Taylor built Fenway Park in 1912, but Bostonians fell in love with the sport in the South End. The South End Grounds opened on the corner of Columbus Avenue and Walpole Street in May 1871 to cheering crowds.

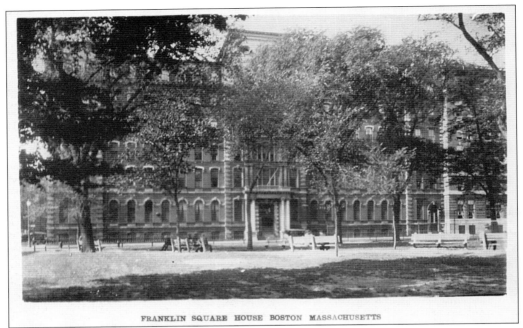

FRANKLIN SQUARE HOUSE BOSTON MASSACHUSETTS

Built in 1867 by Maturin M. Ballou, the Franklin Square House was originally the St. James Hotel. Ballou built this elegant seven-story brick building in the French Second Empire style, drawing influence from the Old City Hall on School Street. With over 400 rooms, the hotel was one of the largest in Boston. It was a hotel for a brief period, afterwards housing the New England Conservatory of Music.

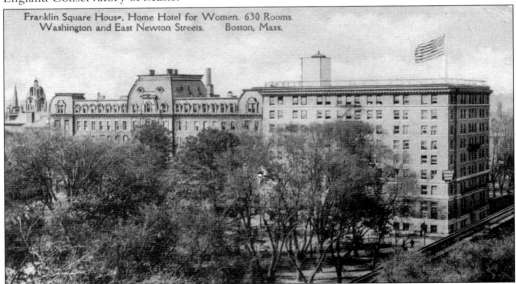

The New England Conservatory of Music (established 1867) is the oldest independent school of music in America. Located across from Franklin Square, it operated in the former St. James Hotel from 1882 to 1901. It had rooms for 550 students and included a concert hall with seating for 2,500 people. By 1900, it was clear that the school needed a larger location, and the conservatory moved to Huntington Avenue in 1903.

90

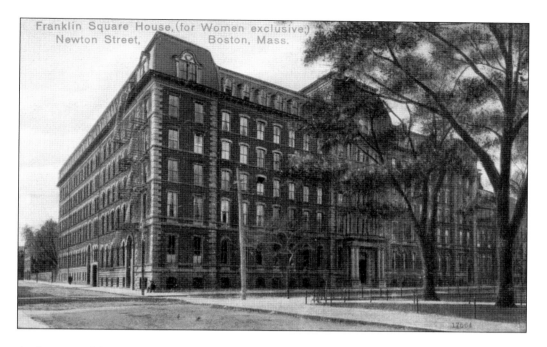

At the turn of the 20th century, most women in Boston were working 60 hours a week for $1 per day. Average housing in the city at the time was about $5 a week, leaving women unable to afford decent housing. Rev. George L. Perin, pastor of the Shawmut Universalist Church, recognized the need to provide affordable housing for women. Perin was not a wealthy man, but he worked tirelessly to raise funds to purchase the former hotel from the New England Conservatory of Music in 1902. Committed to the Franklin Square House for Women, Perin continuously raised funds for the building and even lived on the top floor with his family.

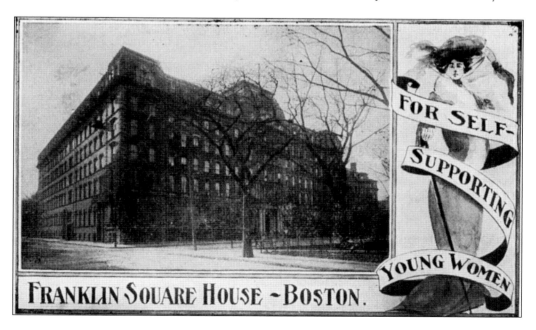

After a few years, the Franklin Square House for Women outgrew the building and, in 1914, built an addition that extended to the corner of Washington Street. The new addition added four hundred rooms, a large dining room, and Grandin Hall. Grandin Hall, pictured above, was the organization's large reception room. It was used as a sitting room for afternoon tea and a reception area for guests and friends. The Franklin Square House named the hall for John L. Grandin, a trustee of the Franklin Square House who volunteered to furnish the room from his own pocket. Note the small rooms under the archways, which were parlors for more private entertaining.

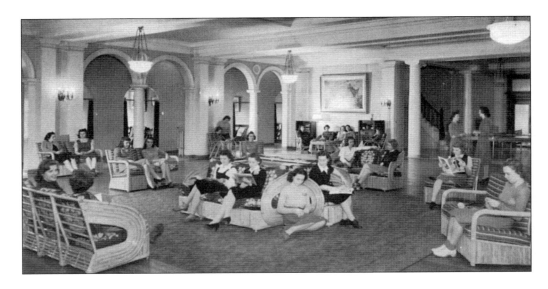

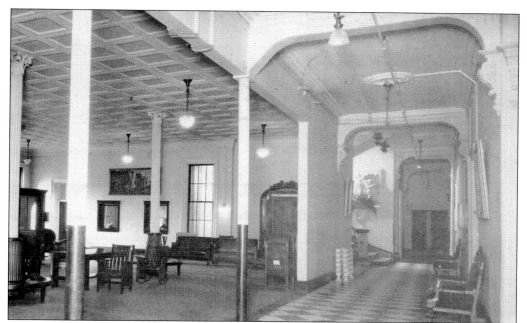

Pictured here is the lobby of the Franklin Square House and one of the many private parlors. The parlors, located in Grandin Hall, were curtained off and allowed residents to privately entertain friends and family as if they were in their own homes. The parlors included several couches, chairs, large windows overlooking Franklin Square and Washington Street, and other décor to make residents feel at home. The Franklin Square House for Women prospered in the South End until 1970. After World War II, it was more common for women to enter the workforce, and they benefited from better working conditions. The building evolved once again to meet the needs of the changing neighborhood, and today it serves as elderly housing.

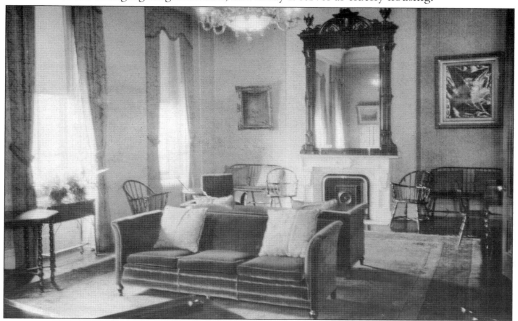

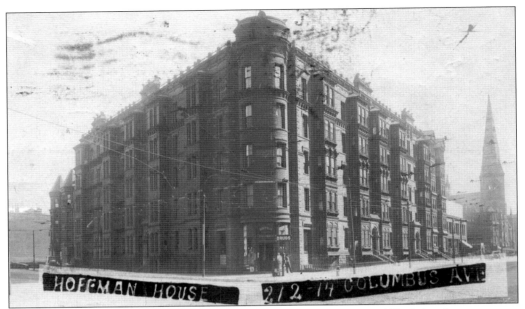

The Hoffman House, located at the corner of Columbus Avenue and Berkeley Street, was an apartment hotel. Apartment hotels became popular in Boston in the late 19th century, many clustered on Columbus Avenue in the South End. Apartment hotels met the needs of Boston's booming population. The Hoffman House, a five-story brick building, also housed offices and the Hoffman Pharmacy on the ground floor.

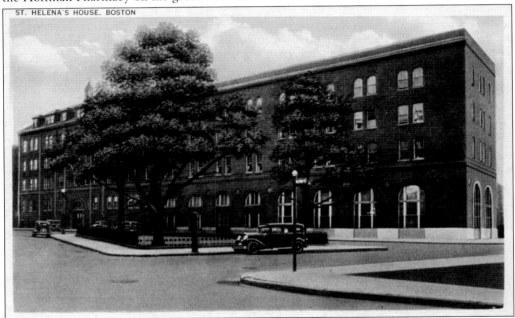

St. Helena's House, also known as the Working Girls' Home, offered affordable housing for young working women in the city. In the 19th century, the Catholic Church and much of society viewed women as vulnerable and did not want those who worked in cities to live in improper or unsafe housing.

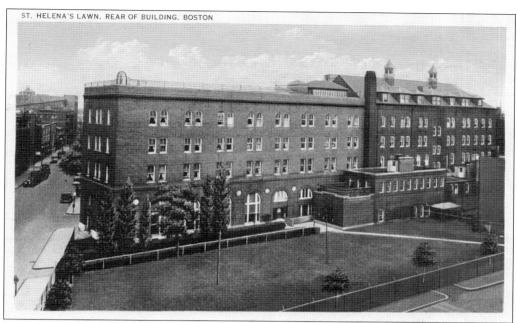

ST. HELENA'S LAWN. REAR OF BUILDING. BOSTON

Archbishop John Joseph Williams recognized the lack of safe and affordable housing in Boston and invited the Grey Nuns of Montreal, Canada, to establish a home for working girls. The Sisters of Charity of Montreal (known as the Grey Nuns) is a religious organization founded by St. Marguerite d'Youville in 1737. Archbishop Williams and the Grey Nuns established the Working Girls' Home at 34 and 36 Dover Street. Its success led to the purchase of land in April 1891 on Union Park Street. Built with brick and granite trimmings, the five-story building housed 200 women. The new building also featured a dining room, gymnasium, reading room, chapel, visitors' parlor, and an employment department.

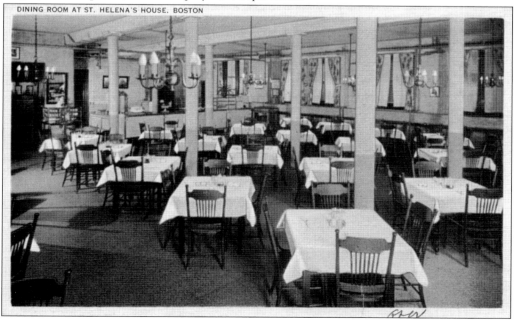

DINING ROOM AT ST. HELENA'S HOUSE. BOSTON

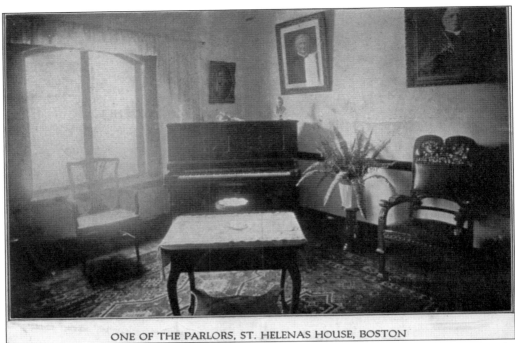

ONE OF THE PARLORS, ST. HELENAS HOUSE, BOSTON

Although the Catholic Church ran St. Helena's House, it welcomed women of all faiths. The home offered accommodation for 200 women and offered more than a place to sleep. Pictured at the top is a typical parlor found at St. Helena's House. Women could entertain their family and friends in one of the many parlors in the building. The artwork and furnishings give the room a home-like feel. Pictured below is the assembly hall, offering receptions and music for St. Helena's guests and residents. Like the Franklin Square House, St. Helena's House was eventually adapted into affordable housing for the elderly.

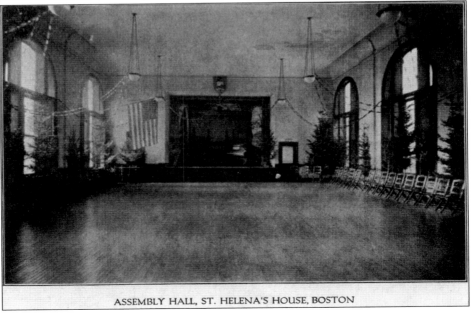

ASSEMBLY HALL, ST. HELENA'S HOUSE, BOSTON

AMATEUR NIGHT AT COLUMBIA MUSIC HALL

- ONE OF BOSTON'S ODD SIGHTS -

The Columbia Theatre opened in 1891 at 978 Washington Street on the site of the former South Congregational Church. Architect Leon Lempert Jr. designed the Columbia Theatre, drawing inspiration from the Alhambra, a palace and fortress in Granada, Spain. The exterior of the building consisted of white brick with terra-cotta trimmings, supported by cast-iron columns and arches.

The Columbia Theatre's auditorium fit 750 people comfortably, and its new design offered a great view from any seat. The Columbia Theatre's opening night was on October 5, 1891. The owner, James J. Grace, wanted the Columbia Theatre to be a model for the rest of the country. Grace succeeded, as newspapers described the new theater as luxurious and impressive.

WHY: HOW'DY DO.

COLUMBIA THEATRE
978 - 986 Washington Street, Boston.
RICH. HARRIS & FROHMAN.
Proprietors and Managers.

Beginning in 1901, the Washington Street Elevated Railway ran adjacent to the Columbia Theatre. Passing trains made it difficult for audiences to hear performances. This problem persisted until the theater's demolition in 1957. Over its history, the Columbia Theatre changed ownership and names. From 1911 to 1937, American business magnate Marcus Loew, known for establishing Loew's Theatres and MGM Studios, purchased the building and renamed it Loew's South End Theatre.

CLUB zara
475 TREMONT STREET · BOSTON, MASS

Located at 475 Tremont Street, on the corner of Dover (today's East Berkeley) Street, was Club Zara, a lively nightclub and restaurant featuring belly dancers. The music and dancing began at 7:00 p.m. every evening, and included a bar for patrons. Today, the building no longer exists and is an empty lot on the edge of the neighborhood, near the East Berkeley Community Garden.

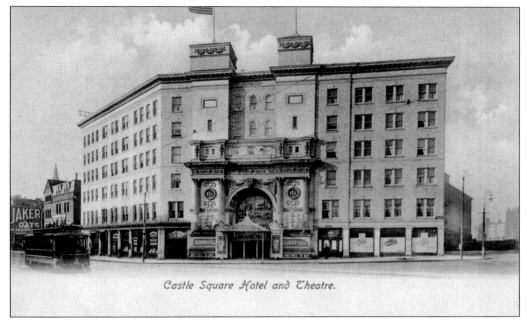

Castle Square Hotel and Theatre.

Walter Winslow and George Wetherell built the Castle Square Hotel and Theatre on Tremont Street in 1894. The Rococo-style building was constructed with white brick, concrete, and iron, fortifying the building against fire. The hotel and theater, while in the same building, were separate entities and run separately. Before the Castle Square Hotel and Theatre, this location was the site of the Bunker Hill Cyclorama, visible in the bird's-eye view below. Winslow and Wetherell, rather than demolishing the cyclorama, incorporated it into the theater's design. The hotel had 500-rooms with private bathrooms in each and was richly furnished with velvet carpets and Turkish and Indian rugs.

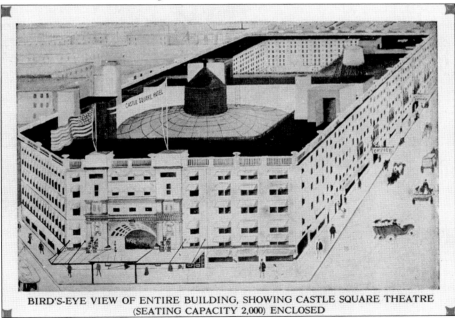

BIRD'S-EYE VIEW OF ENTIRE BUILDING, SHOWING CASTLE SQUARE THEATRE
(SEATING CAPACITY 2,000) ENCLOSED

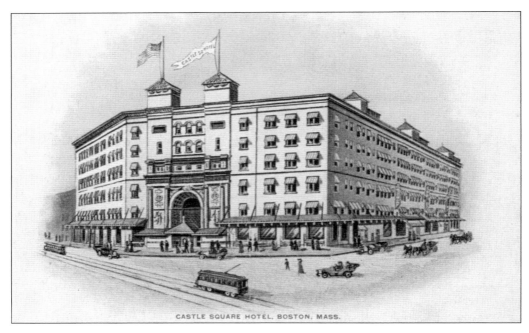

CASTLE SQUARE HOTEL, BOSTON, MASS.

The Castle Square Theatre accommodated almost 2,000 people and put on six matinees and six performances per week. The theater's entrance was at the junction of Tremont, Ferdinand (now Arlington), and Castle (now Herald) Streets. The theater was so large that it included a stock company and performance troupe. The Castle Square Dramatic Stock Company produced 212 different plays for the theater between 1897 and 1903. Despite the Castle Square Theatre's popularity in Boston, it closed during the Depression and was demolished in 1933. Today, it is the location of the Animal Rescue League of Boston, which moved to the site in 1956.

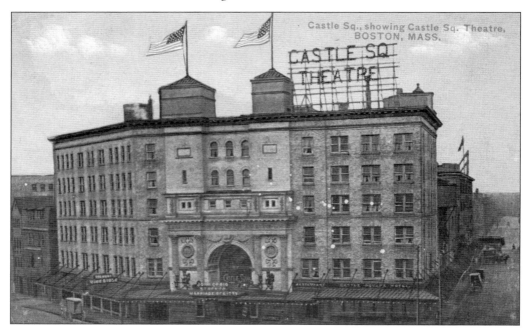

Castle Sq., showing Castle Sq. Theatre, BOSTON, MASS.

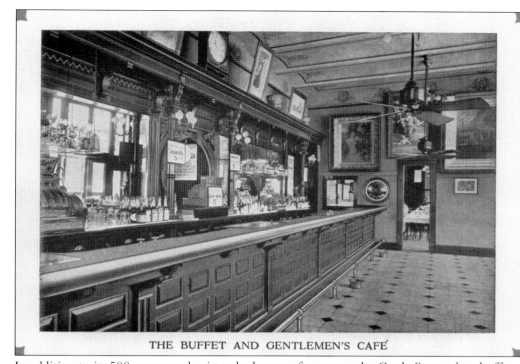

THE BUFFET AND GENTLEMEN'S CAFÉ

In addition to its 500 rooms and private bathrooms for guests, the Castle Square hotel offered separate entertaining and dining spaces for men and women. Pictured here is the gentlemen's café and one of the many ladies' parlors. The Castle Square Hotel also offered special dining rooms for women. In the 19th century, it was common for hotels to offer dining rooms and cafes reserved specially for women. Segregating men and women guaranteed that women would not be subject to lewd behavior or tarnished reputations. While some thought women dining alone outside of the home indecent, the number of single working women in cities necessitated the need for ladies' dining spaces.

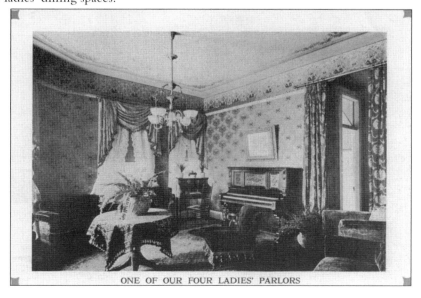

ONE OF OUR FOUR LADIES' PARLORS

SECTION OF GARDEN, SITUATED IN CENTRE OF HOTEL

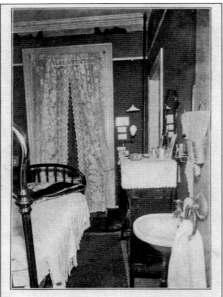

Front Single Room on Bath Room Floor

The Best Lodging House in Boston.
THE GERALD
37 WEST NEWTON STREET, BOSTON, MASS.
Rates, $2.00 per week and upwards.

The Castle Square Hotel and Theatre was located in a bustling part of the South End. Walter Winslow and George Wetherell built the hotel around a courtyard and garden. This unique open space offered a place for guests for relax. The courtyard's location in the center of the hotel provided every room with natural light.

The Gerald Lodging House was located at 37 West Newton Street, across from Blackstone Square. It offered rooms with a shared bathroom on each floor. Originally, row houses in the South End were built as single-family homes. By the end of the 19th century, most of the buildings were converted into money-making lodging houses. As owners converted buildings into rooming houses to serve the working population, the ground floors became a space for commercial activity.

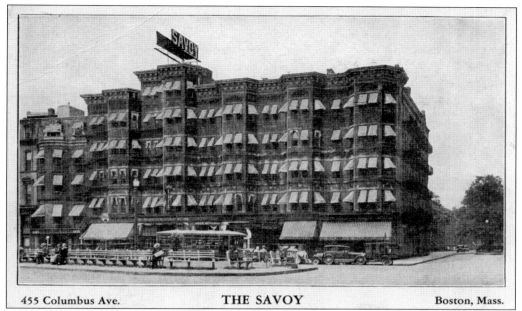

455 Columbus Ave.　　　　　**THE SAVOY**　　　　　Boston, Mass.

The Savoy Hotel was located at 455 Columbus Avenue, near Braddock Park and Columbus Square. The hotel offered 200 rooms and suites for guests, with private bathrooms and telephones in each room. The ground floor featured a first-class restaurant with live music. The hotel, like many in the South End, was available for temporary and permanent guests.

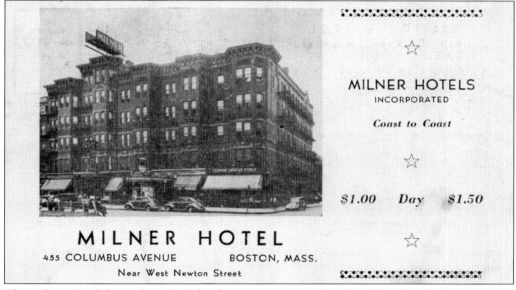

☆

MILNER HOTELS
INCORPORATED

Coast to Coast

☆

$1.00　*Day*　$1.50

☆

MILNER HOTEL
455 COLUMBUS AVENUE　　　BOSTON, MASS.
Near West Newton Street

The Milner Hotel, located at 455 Columbus Avenue, was a short-lived hotel in the late 1930s and early 1940s near Braddock Park. It was originally known as the Savoy Hotel and switched back to its previous name after several years. The city demolished the building, which encompassed an entire block, in 1969.

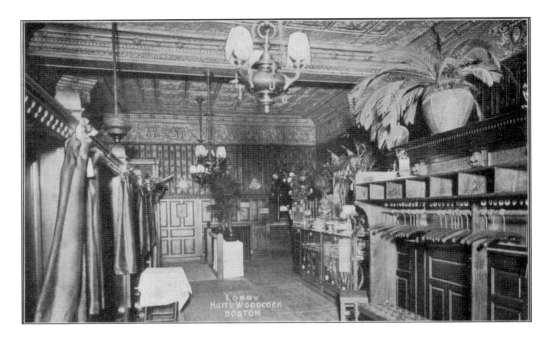

Walter P. Ruisseau founded the Hotel Woodcock in 1879 at the young age of 30. The hotel, located at 1039 Washington Street at the corner of Cherry Street soon became a popular hotel in the city. Ruisseau was born in Nashville, Tennessee, in 1849 and was the son of a surgeon in the Confederate army. Ruisseau moved to New York and worked as the manager of French's Hotel before venturing out on his own in Boston. Pictured here is the hotel lobby and dining room. The hotel was known for its fine dining, which featured live music in the evening. Note the elaborate ceiling detail, woodwork, and decorations.

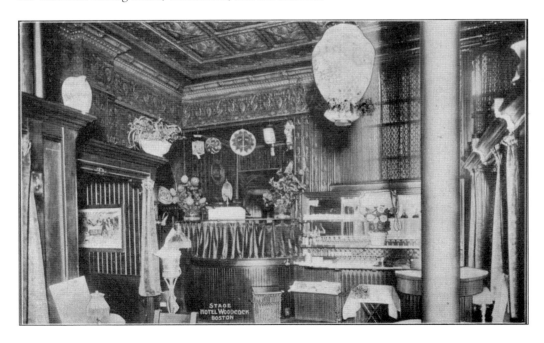

Despite Hotel Woodcock's proximity to downtown Boston, the Ruisseau family established a taxi service to transport hotel guests to and from the train station. The popular hotel was later incorporated as the Hotel Woodcock Company in 1908. The elaborate design and detail was not continued throughout the entire hotel. Unlike the lobby and dining room, the kitchen and sunken garden featured a simpler design. Founder Walter P. Ruisseau retired in 1900 but served as president of Hotel Woodcock while his sons Fred and Walter Ruisseau Jr. managed the hotel. Hotel Woodcock closed several years after Walter P. Ruisseau's death in 1915.

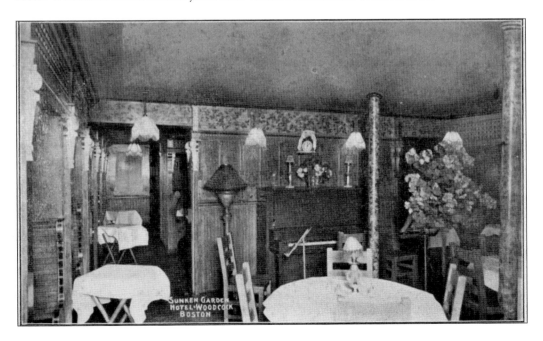

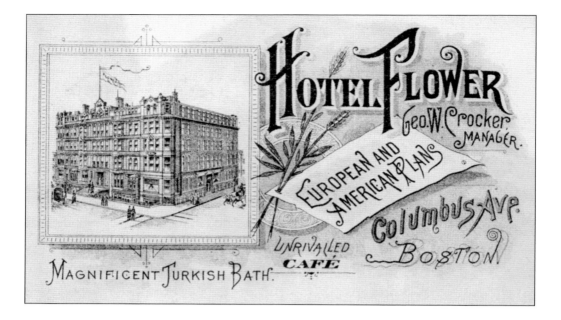

Built in 1878, this High Victorian Gothic building was nestled between Berwick Park (now Braddock Park) and Holyoke Street. In 1889, Richard Charles Flower purchased the building at 419 Columbus Avenue and named it the Flower Hotel. This popular hotel featured public Turkish baths, a deep-sea saltwater bath, and steam rooms. Over the course of its history, the building was home to a succession of hotels, including the Hotel Plaza. The Hotel Plaza, in addition to the usual rooms found in a first-class hotel, featured themed rooms, including a grape room and a Dutch room with windmill decorations.

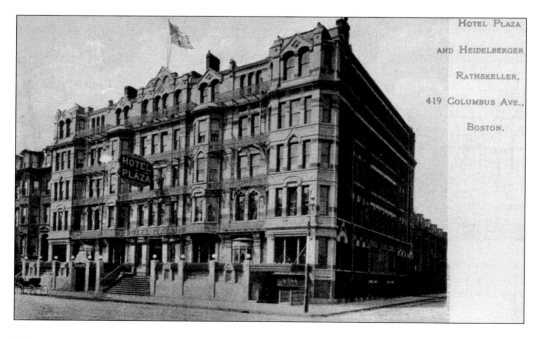

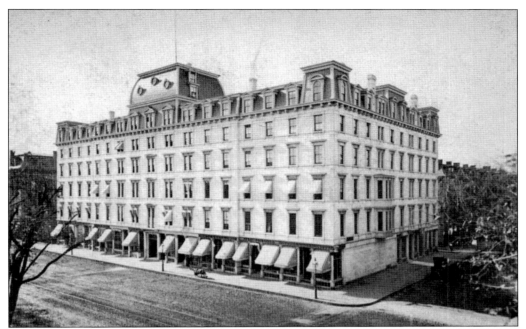

The Commonwealth Hotel, built in 1869–1870, was a residential hotel located at 1697 Washington Street. It was built in the French Second Empire style and featured a marble façade and mansard roof. The French Second Empire style was a popular style in the latter half of the 19th century and frequently found throughout the city.

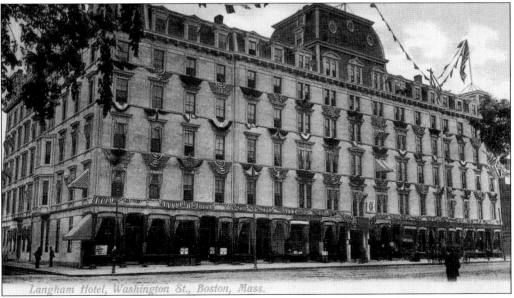

Langham Hotel, Washington St., Boston, Mass.

In 1889, the Commonwealth Hotel changed its name to the Langham Hotel after Henry Bigelow Williams purchased the building. Williams was also the owner of the Hotel Brunswick and Hotel Victoria. After purchasing the hotel, Williams began renovating the building. Fleur-de-lis adorned the wall and ceiling of the lobby and featured an elegant marble staircase. After several fires in 1971, the city demolished the building.

Red Sox owner John Taylor built Fenway Park in 1912, but Boston's love affair with baseball began almost 150 years ago in the South End. The South End Ground opened on Columbus Avenue and Walpole Street (now Cyprian's Church) on May 16, 1871. A new and much larger baseball field was built in 1888, pictured here. Also referred to as the "Grand Pavilion," it had a large double-decked grandstand behind home plate. Unfortunately, the second location was short-lived. On May 15, 1894, the Great Roxbury Fire destroyed the stadium and over 100 other buildings. The reason for the fire is still unknown. Some stories say a fan lit a cigar during the baseball game that fell through the bleachers, causing a fire. Other accounts say a group of boys set a small fire under the bleachers. What is known is that a fire ignited under the right-field bleachers and demolished the baseball stadium and the surrounding area.

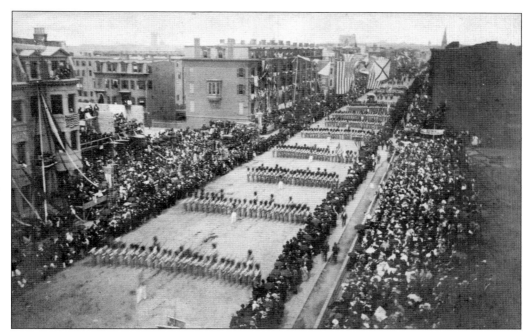

On June 17, 1875, Boston celebrated the centennial of the Battle of Bunker Hill. The battle, one of the first of the Revolutionary War, demonstrated to the British that an inexperienced militia could stand up to the troops in battle. Boston declared June 17, 1875, a public holiday and organized a grand parade. Pictured here is the parade on Columbus Avenue, which was particularly grand, with buildings richly decorated with flags, banners, and bunting.

The Parade of the Knights Templar took place in Boston in 1895. The parade strode down Washington Street on August 27, 1895, toward downtown Boston. This photograph was taken from Franklin Square, with the grandstand at Blackstone Square across the street. Boston decorated its streets and buildings elaborately for the parade. The Knights Templar is a fraternal order associated with Freemasonry.

Chicago businessman Charles F. Willoughby commissioned Cummings & Sears to build the Gettysburg Cyclorama on Tremont Street. Cycloramas were a popular form of entertainment in the 19th century where a panoramic mural was placed inside of a building, allowing visitors a 360-degree view of an image. Like most cycloramas, the one on Tremont Street depicted a battle scene. French artist Paul Philippoteaux painted *The Battle of Gettysburg* for the cyclorama. This life-sized mural measured 50 feet high, 400 feet long, and weighed almost three tons. In addition to the mural, replicas of soldiers, artillery, terrain, and other objects were placed between the painting and visitor to make it feel as though one had walked right onto the battlefield. By 1889, interested in cycloramas diminished and the building took on a series of uses, such as a roller-skating rink, bicycle-riding school, and a flower market. Today, the building is home to the Boston Center for the Arts, while *The Battle of Gettysburg* is now located at Gettysburg National Military Park.

Seven

BUSINESS AND INDUSTRY

The South End was a hub for industry in the 19th century. Here, one found lumber and coal companies, horse stables, and countless family-run businesses. But the neighborhood was probably best known for its piano manufacturing. In 1902, there were 11 piano factories in the neighborhood. The biggest and most well known was Chickering & Sons. In the mid-19th century, Chickering & Sons was the largest piano manufacturer in the country. After a devastating fire at its factory on Washington Street, Chickering moved into the neighborhood on Tremont Street, close to Chester Square.

Single-family row houses began to evolve into tenement and lodging houses in the late 19th century, and building owners needed to serve the South End's working-class population. The solution was the establishment of a number of family-run restaurants, cafes, grocers, and drugstores on the ground floor of buildings. Today, when walking through the South End, one will still find a blend of commercial and residential space on any of the main streets in the neighborhood.

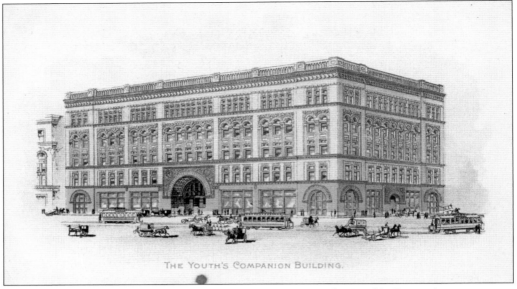

THE YOUTH'S COMPANION BUILDING.

The *Youth's Companion* was an American children's magazine, first published by Nathaniel Willis and Asa Rand in 1827. When first launched, the magazine wrote for children and focused on religion. By the 1890s, the magazine's content shifted to entertainment and targeted adults as well as children. Famous writers such as Mark Twain, Emily Dickinson, Jack London, and Harriet Beecher Stowe contributed to the magazine.

The *Youth's Companion* building is located at the corner of Columbus Avenue and Berkeley Street. Architects William Cummings Richardson and Henry Hartwell designed the five-story Romanesque building in 1892, and it served as headquarters for the *Youth's Companion* from 1892 to 1915, when it moved to a new facility near Boston University.

In 1888, the *Youth's Companion* began a campaign to sell US flags to public schools to solicit more subscribers. Under the flag promotion, the magazine became an ardent supporter of the schoolhouse flag movement, which sought to place a flag in every school in the country. The flag promotion was a success for the *Youth's Companion*, and by 1892 the magazine sold flags to 26,000 schools. In 1891, owner and editor Daniel Ford hired Francis Bellamy to work with Ford's nephew James Upham in the magazine's premium department. The following year, the magazine used the 400th anniversary of Christopher Columbus reaching the Americas to further the schoolhouse flag movement. It called for a national Columbian Public School celebration to coincide with the Chicago World's Fair. Francis Bellamy wrote the Pledge of Allegiance for the celebration, and the *Youth's Companion* published it in its September 8, 1892, issue.

Pictured here is the magazine's library, which had a collection of clippings from hundreds of magazines. The entire building housed the *Youth's Companion*, with the business office, correspondence, subscription, and advertising departments on the first floor. The premium department, mailing room, and stitching machines were located on the third floor, and the fifth floor included the editorial offices, art department, and library.

The *Youth's Companion* published its final issue in 1929. The magazine merged that same year with its rival, the *American Boy*, a monthly magazine that published action stories for boys. Although no longer headquarters for the *Youth's Companion*, the National Parks Service added the building to the National Register of Historic Places in 1974. Today, the building houses several businesses.

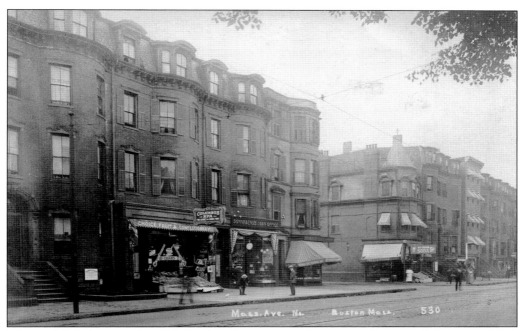

This mislabeled postcard is of Columbus Avenue, near the corner of Yarmouth Street, in 1912. Featured in the photograph is Sonnabend's Loan Office, located at 373 Columbus Avenue. Sonnabend's was a pawnshop owned by Louis Sonnabend. The City of Boston demolished this block of Columbus Avenue in the late 1960s.

Chickering & Sons was an American piano manufacturer in Boston. Jonas Chickering founded the company in 1823 with James Stewart, a piano maker. By 1827, Chickering worked independently to transform his company into a global industry. By the mid-19th century, Chickering & Sons was the largest piano manufacturer in the United States.

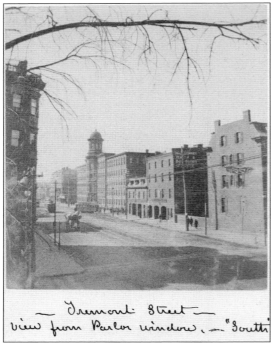

Tremont Street — view from Parlor window, — "South"

On December 1, 1852, a devastating fire destroyed Chickering's factory at 336 Washington Street in Boston. The fire was so large that it set adjacent buildings on fire. Looking for a new factory location, Jonas Chickering chose the South End. Unfortunately, Jonas Chickering never saw his new factory, as he died of a stroke months before its completion in December 1853. Pictured here is the factory on Tremont Street.

Architect Edward Payson designed the modern steam-powered factory under Jonas Chickering's specifications. In the mid–19th century, the factory at 791 Tremont Street was the second largest building in the United States, second only to the Capitol Building in Washington, DC. Developers renovated the building into artists' galleries and apartments in 1972. Today it is known as the Piano Factory.

Samuel and Henry Smith founded the Smith American Organ and Piano Company in 1834. The company originally built high-end organs, expanding to pianos in the early 1880s. The company built the factory at 531 Tremont Street in 1865. Today, that building is part of the Boston Center for the Arts complex and includes artist studios, galleries, and a restaurant.

James Whiting Vose established Vose Pianos in 1851. Born in Milton, Massachusetts, Vose learned cabinetmaking before taking an interest in piano manufacturing. Vose's three sons joined the company in 1889, and the company name changed to Vose & Sons. The company enjoyed success and outgrew its factory in Boston, moving to Watertown in the early 20th century. During the Great Depression, many businesses suffered and Vose became part of the Aeolian-American Corporation.

BRIGGS PIANOS.
5 APPLETON ST., BOSTON.

Charles C. Briggs founded Briggs Pianos in 1868. Born in Boston, Briggs apprenticed under Albert W. Ladd and worked for the Emerson Piano Company as a foreman before venturing out on his own. He partnered with his son to form Briggs Pianos. Originally located at 1125 Washington Street, Briggs Pianos moved to a six-story factory at 5 Appleton Street on the edge of the South End. Known for its upright pianos, the quality and design of Briggs pianos quickly made the company a top manufacturer in Boston. After 1912, the National Piano Manufacturing Company took control of several prominent piano manufacturers, including Briggs Pianos. The company later went out of business before the onset of the Great Depression.

Established in 1839, Hallet & Davis is among the oldest piano manufacturers in Boston. In 1864, a fire devastated the Hallet & Davis factory. A new factory was soon built on Harrison Avenue in the South End, between East Canton and East Brookline Streets. Hallet & Davis built the new five-story facility in the French Second Empire style. During the Great Depression, Hallet & Davis became part of the Aeolian American Corporation. Established in 1903, the Aeolian American Corporation was one of the largest and most successful piano companies in the United States, acquiring rival piano manufacturers in the 20th century.

Compliments of the

Hallet & Davis Piano Co

FOUNDED 1896

EASTERN SMELTING & REFINING CORP.

Smelters and Refiners of

GOLD · SILVER · PLATINUM

107-109 W. BROOKLINE ST.
BOSTON, MASS.

THIS IS THE MAIN PLANT
GENERAL OFFICES & LABORATORIES

ESTABLISHED · 1901

The Wellington Café

MUSIC EVERY EVENING & SUNDAY AFTERNOONS

TELEPHONE 21622 TREMONT
OPEN FROM 6 A.M TILL MIDNIGHT.
569 COLUMBUS AVE. BOSTON, MASS.
PHILOS & KLURIS, PROPRIETORS.

The Eastern Smelting & Refining Corporation, located at 107–109 West Brookline Street, was founded in 1896. It specialized in extracting valuable metals, such as gold, silver, platinum, and palladium from raw materials. Smelting, which means to extract metal from raw materials using heat, can have a negative impact on the environment through soil and air pollution.

Constantine Philos and Charles Kluris established the Wellington Café in 1901 at 569 Columbus Avenue. Located near the corner of Massachusetts Avenue, the restaurant featured music every evening and was open until midnight. However, the Wellington Café was short-lived, and a public auction sold the cafe's interior in March 1926.

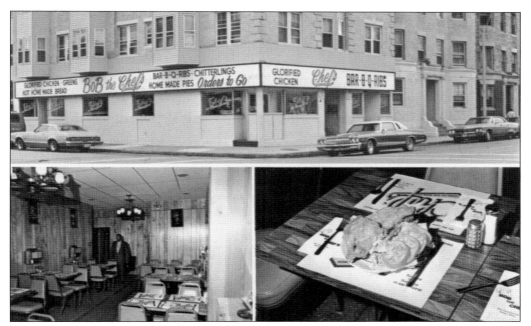

Bob and Annie Morgan opened Bob the Chef's at 604 Columbus Avenue in the early 1960s. Morgan's soul food restaurant soon became a South End institution, known for its "glorified chicken." Darryl Settles purchased the restaurant in 1990, and today, one can still enjoy Southern cuisine with a side of live jazz at Darryl's Corner Bar & Kitchen.

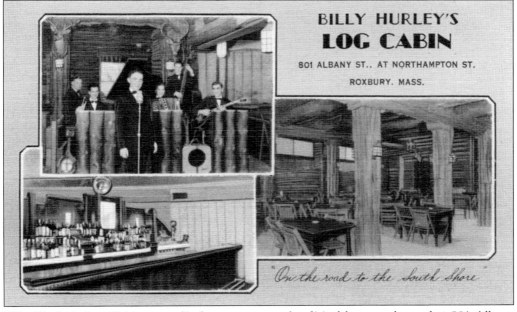

Billy Hurley's Log Cabin was a lively restaurant and political hot spot located at 801 Albany Street, at the corner of Northampton Street. William "Billy" Hurley owned the restaurant but sold it in 1945 to focus on politics. He was on the Boston City Council for 20 years and twice served as president of the council.

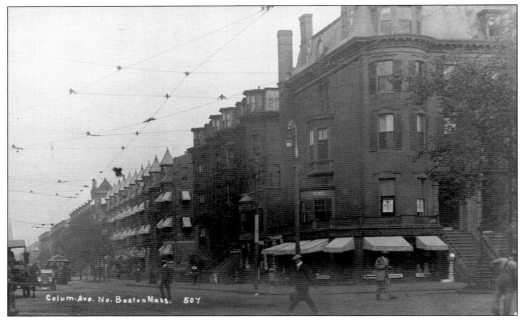

Magullion & Company, located on the corner of Columbus and Massachusetts Avenues, was a local grocery and liquor store. The company formed in 1894 and owned several businesses in the South End, including a liquor store and bar at the corner of Dover (now East Berkeley) and Tremont Streets. The original building no longer exists, and the site is the location of United South End Settlements.

Horace Draper and Andrew Jackson Hall opened Draper & Hall at 91 West Dedham Street in 1868. Starting small, their horse stable and riding school soon found success and expanded into one of the most prominent and largest stables in Boston. The horse stable was on the ground floor, which accommodated over 300 horses. In the 1880s, Draper became the primary owner of the company as Hall shifted into politics.

W.W. Stall was a bicycle and tricycle shop located in Odd Fellows Hall at 509 Tremont Street. William W. Stall, an avid bicyclist, owned the store. In the late 19th century, Boston was the center of the bicycle craze. The first bicycle club in the country, the Boston Bicycle Club, formed in 1878. For a time, Boston was known as the "bicycling paradise of America."

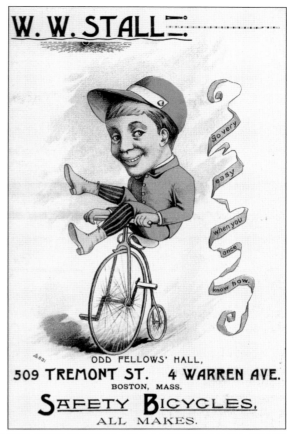

On the ground floor of the Hotel Plaza was the famous Heidelberger Rathskeller, a German restaurant that featured a Hungarian orchestra. Rathskeller is a term in German-speaking countries for a restaurant, bar, or tavern located in the basement of a city building. The restaurant, which seated over 100 people, was decorated with wooden panels, hand-carved pillars, and nine panels depicting German scenery.

Frank Janes Pharmacy was located at the corner of Massachusetts and Columbus avenues in the early 20th century. It was a general store and pharmacy, owned by Frank and Bertha Janes. Born in Armenia in 1879, Frank Janes immigrated around 1895 to the United States, where he met his wife, Bertha Chase. Frank and Bertha were members of the National Association of Retail Druggists, and they later purchased drugstores on Harrison Avenue and on the corner of Tremont and Dover (now East Berkeley) Streets. Today, Frank Janes Pharmacy, pictured here, is the location of Dunkin' Donuts.

Johnny Corey's Café was a restaurant and bar located at 53 Northampton Street near the corner of Harrison Avenue. John Corigliano owned the restaurant, as well as Johnnie's Barber Shop, located just a few doors down at 57 Northampton Street. Before it was Johnny Corey's Café, it was the South Side Tavern, owned by Corigliano's father. Today, the location is a car garage.

The Savoy Café opened in 1935 at 461 Columbus Avenue. The restaurant moved eight years later to 410 Massachusetts Avenue, where it became known as the Savoy and featured live jazz music. In the early and mid-20th century, the South End was the spot for jazz music. People of all ages flocked to the South End for its many jazz clubs occupying the neighborhood.

Selected Bibliography

Card, Richard O. *Boston's South End: An Urban Walker's Handbook*. Boston: South End Historical Society, 1992.

Cheever, David W. *A History of the Boston City Hospital from Its Foundation until 1904*. Boston: Municipal Printing Office, 1906.

Deutsch, Sarah. *Women and the City: Gender, Space, and Power in Boston, 1870–1940*. New York: Oxford University Press, 2000.

Goodman, Phebe S. *The Garden Squares of Boston*. Lebanon, New Hampshire: University Press of New England, 2003.

Hartley, Benjamin L. *Evangelicals at a Crossroads: Revivalism & Social Reform in Boston, 1860–1910*. Durham, New Hampshire: University of New Hampshire Press, 2011.

King, Moses. *King's Handbook of Boston*. Boston: 1881.

Lopez, Russ. *Boston's South End*. Boston: Shawmut Peninsula Press, 2015.

Lukas, J. Anthony. *Common Ground: A Turbulent Decade in the Lives of Three American Families*. New York: Vintage Books, 1986.

Petronella, Mary Melvin. *Victorian Boston Today: Twelve Walking Tours*. Boston: Northeastern University Press, 2004.

Sammarco, Anthony Mitchell. *Boston's South End*. Charleston, SC: Arcadia Publishing, 2004.

Seasholes, Nancy S. *Gaining Ground: A History of Landmaking in Boston*. Cambridge, MA: The MIT Press, 2003.

Shannon, Hope. *Legendary Locals of Boston's South End*. Charleston, SC: Arcadia Publishing, 2014.

About the South End Historical Society

A group of residents who recognized the significant architectural quality of the South End founded the South End Historical Society in 1966. Through the efforts of the historical society, the South End has been listed in the National Register of Historic Places as the largest Victorian brick row house district in the United States.

The South End Historical Society is dedicated to historic preservation and education in Boston's South End. The historical society offers lectures and walking tours about the South End's rich social and architectural history, and encourages research, conservation, and education to promote interest in our historic neighborhood. The South End Historical Society is located in Chester Square at 532 Massachusetts Avenue. For more information on the historical society, please visit www.southendhistoricalsociety.org.

THE SOUTH END HISTORICAL SOCIETY

DISCOVER THOUSANDS OF LOCAL HISTORY BOOKS FEATURING MILLIONS OF VINTAGE IMAGES

Arcadia Publishing, the leading local history publisher in the United States, is committed to making history accessible and meaningful through publishing books that celebrate and preserve the heritage of America's people and places.

Find more books like this at
www.arcadiapublishing.com

Search for your hometown history, your old stomping grounds, and even your favorite sports team.